DRAWING
FIGURES

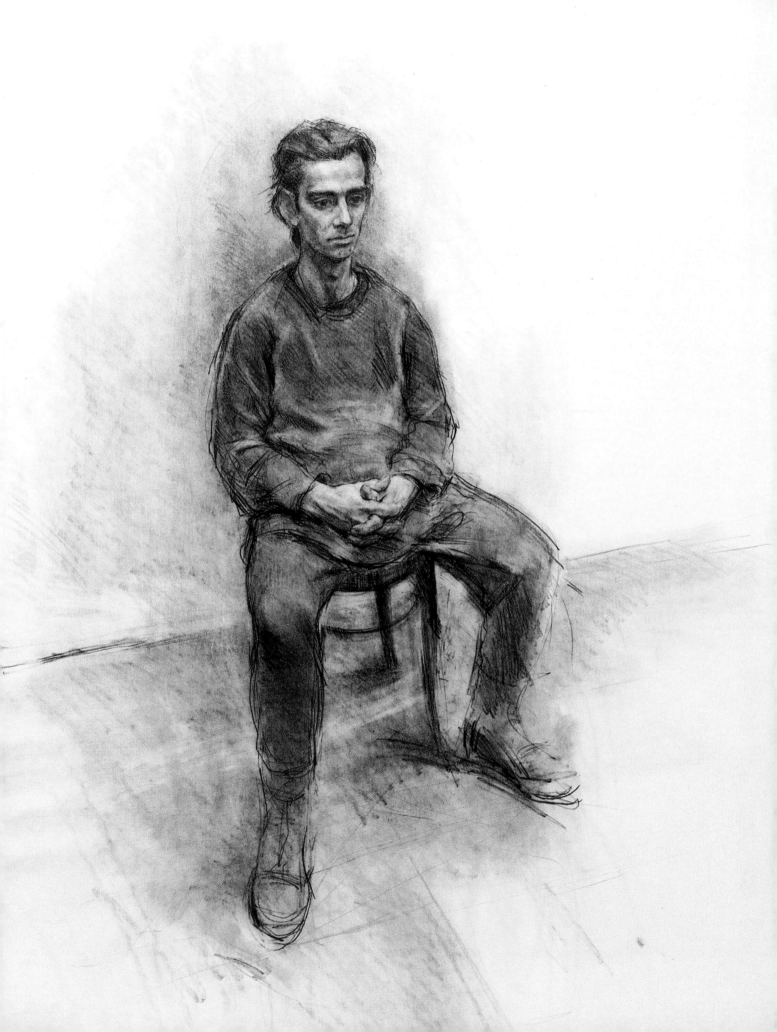

Art School

DRAWING
FIGURES

RAY SMITH

A DORLING KINDERSLEY BOOK

Project editor Louise Candlish
Art editor Claire Pegrum
Senior editor Gwen Edmonds
Managing editor Sean Moore
Managing art editor Toni Kay
DTP designer Zirrinia Austin
Production controller Meryl Silbert
Picture researcher Jo Walton
Photography Steve Gorton

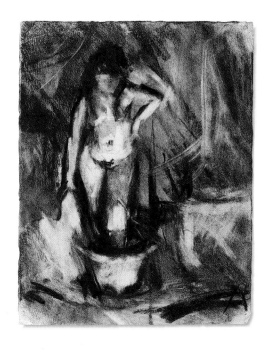

First published in Australia in 1994 by RD Press
a registered business name of
Reader's Digest (Australia) Pty Limited
26-32 Waterloo Street, Surry Hills, NSW 2010

Copyright © 1994
Dorling Kindersley Limited, London

The National Library of Australia Cataloguing-in-Publication data

Smith, Ray, 1949–.
 Drawing figures.

 ISBN 0 86438 537 4.
 ISBN 0 86438 486 6 (series)

 1. Figure drawing - Technique. I. Royal Academy of Arts
(Great Britain). II. Title. (Series : Art school).

743.4

Colour reproduction by Colourscan in Singapore
Printed and bound by Graphicom in Italy

CONTENTS

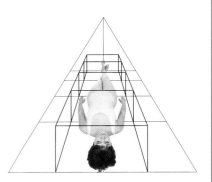

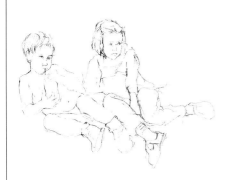

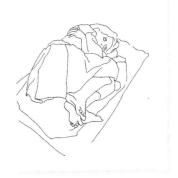

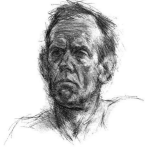

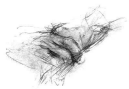

INTRODUCTION

WE COME TO UNDERSTAND something of the world we inhabit through our relationships with other human beings. This interaction is, of course, at the centre of our experience. Drawing the figure gives expression to these important relationships; it describes how we see the world and how we see ourselves within it. When children first draw anything recognizable, it is always the human figure. Throughout our lives, figure drawing allows us to express our relationships with other people at a number of different levels. We can explore the subtle intimacies of friendship and love or we can investigate the figure with a cooler, more objective vision.

Figure drawing is an important form of expression from an early age.

Relating to the figure

In figure drawing, much can depend on the way in which we approach the subject and on the materials we use, rather than on our actual relationship with the subject. In fact, some of the most intense, emotionally charged drawings have been made of subjects with whom the artist had no special relationship.

One important aspect of our approach is our actual size as human beings. We give scale to the world around us. Most of us can remember, for example, how very different it felt to experience the world from a higher viewpoint when, as children, we were held up to adult eye level. So when we draw figures, we are particularly aware of how they fit into their setting, of how greatly their appearance and attitudes may be dictated by the circumstances in which they find themselves.

Getting started

The figure is at the centre of art just as it is at the centre of all our lives. This book tries to give an indication of the richness and variety of a core subject in drawing. If you are relatively new

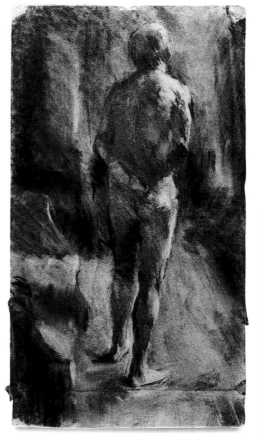

Versatile media

The particular feel of charcoal, with its dense, velvety tones and atmospheric effects, has long made it a favoured medium for figure drawing. It can be rubbed smooth with the fingertips for tonal work or used boldly for linear work. It is also easily erasable for highlights.

Brush drawing

Brushes are not exclusive to painting. In fact, the brush is as important a tool for figure drawing as a pencil or stick of charcoal. There is a thrilling immediacy about a brush drawing that offers you only one chance to get it right.

Drawing from life

In this hand-coloured study, made in 1811 by Thomas Rowlandson, the artist mocks what he sees as the male voyeurism of the Royal Academy life room. Today, figure drawing is less concerned with visions of idealized beauty and more with people as they really are.

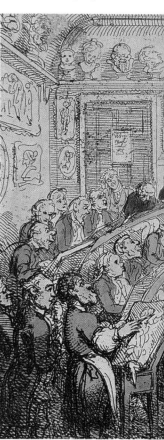

to figure drawing, you may feel daunted by the apparent complexity of the subject. The projects in the "Getting Started" section may help you come to terms with the idea that drawing the figure is not only possible, but need not be at all intimidating either. These projects include making simple line sketches from photographs and from small model figures and other sources that give an idea of how the human figure is constructed. These exercises are not just for the absolute beginner; they can be equally helpful to the more experienced artist.

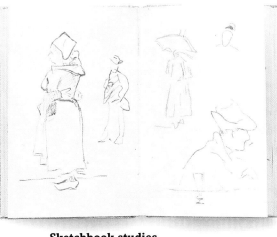

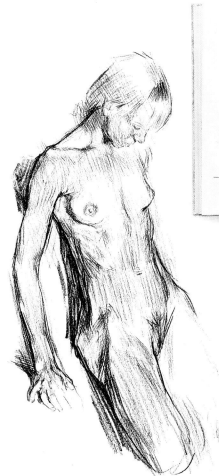

Sketchbook studies

Artists keep sketchbooks with them at all times in order to make visual notes of the figures they see. Here, Gauguin shows his interest in profile and shape. The studies are arranged on the pages of his sketchbook in a quiet and harmonious symmetry.

The nude figure

Drawing the nude body is one of the most challenging disciplines in art. A good knowledge of anatomy and of the way the body moves is helpful. Here, fluid pencil lines capture the proportions of the figure and express the elegance of the pose.

Themes and techniques

The book explores ways of getting to know the anatomy of the figure without having to pore over textbooks or dissect corpses. It also demonstrates ways of making careful, accurate drawings from a variety of poses and in a number of different drawing media. Line, tone and the various ways of modelling three-dimensional form are all explored. In addition, there are exercises in rapid sketching using a number of different approaches, all of which can be a helpful means of establishing accuracy and likeness. There are projects focusing on themes such as mood, atmosphere and composition. Others explore the moving figure, the grouping of figures and the characteristics of youth and age. Many artists use figure drawing as preliminary work towards painting or sculpture, so this aspect of the subject is also investigated. Experimental ways of drawing the figure, such as drawing with a computer – a tool that more and more artists are incorporating into their technical repertoire – are included.

Developing your own style

Above all else, figure drawing is about developing your own style and creating studies with their own atmosphere and meaning. The best way to do so confidently is by drawing as much and as often as you can, and with as much focus and concentration as you can muster.

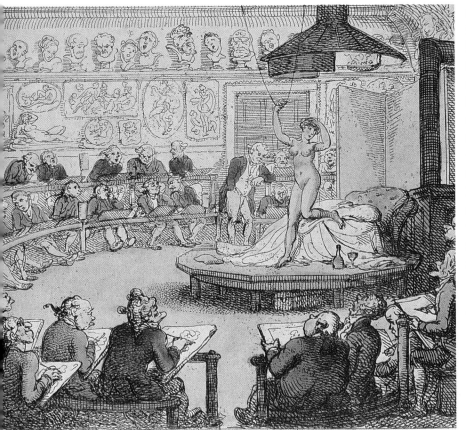

DRY MATERIALS

How your drawing looks depends as much on the medium you use to make it as on your style. In fact, the medium can, to a large extent, dictate the style you adopt. Among the dry materials used for figure drawing are graphite pencils, pigmented crayons, pastels, chalks and charcoal. In addition, there are less common materials, such as silverpoint. Each of these materials has its own feel and allows you to draw in a way that none of the others can, so make a point of trying a number of drawings using each of them in various ways.

A soft graphite pencil gives a rich, fluent line, capturing the immediacy of this stretching pose and giving a solid sense of the shape of the figure through the loose clothes.

2B pencil

6B pencil

Graphite pencils

Pencil leads are made by firing a mixture of powdered graphite and clay and then impregnating them with molten wax. They come in a wide range of grades, from extra hard (9H) to very soft (8B), depending on the proportion of clay to graphite. A soft lead will give a deep, velvety line and soft tonal effects, while a hard lead will give a sharper, more scratchy look. You can choose from wood-encased pencils, chunky graphite sticks or clutch pencils.

This figure drawing has been made with a fine hard lead in a clutch pencil.

Erasers

Erasers are useful and positive drawing tools. Among the different varieties are the white plastic ones, which are efficient and clean, and the putty variety, which can be moulded into a point for precise work or rolled around on the drawing to modify areas of tone.

Putty eraser

Plastic eraser

Conté crayons

Conté crayons respond well to most surfaces, giving a strong, smooth mark.

Conté crayons

A Conté crayon, with its rich pigmentation, often in red or brown iron oxides, gives a soft tonal effect that brings out the grain of the paper. Use the sharp edge of the crayon for line and the flat broad edge for tone. Orange-red is a traditional colour for figure drawing.

Charcoal

Willow charcoal comes as carbonized twigs in a variety of thicknesses. Vine charcoal comes in larger chunks. You can exploit both for their splintery rough feel and unique linear and tonal qualities. Compressed charcoal is made from Lamp Black pigment and gives a very dark tone.

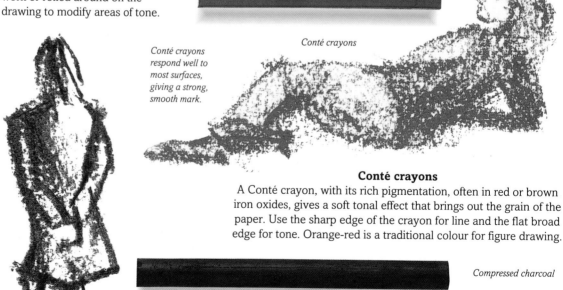

Compressed charcoal

Willow charcoal

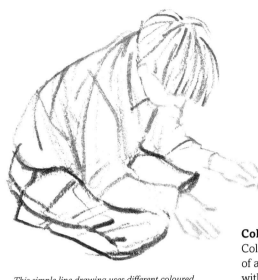

This simple line drawing uses different coloured pencils to define each aspect of the figure.

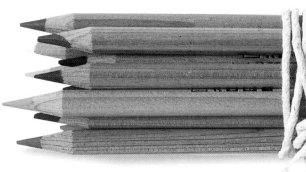

Coloured pencils

Coloured pencils

Coloured pencils are wood-encased sticks of a mixture of pigment and chalk, bound with gum and impregnated with wax. Some varieties are water-soluble, so can be modified with brush and water. Like graphite pencils, they can be sharpened into a fine point to make delicate marks.

Soft pastels come in a wide range of colours.

Figure drawn in oil pastel.

Oil pastels

Oil pastels are a mixture of pigment, wax and fat. They have a thick, sticky feel that makes them a very immediate medium.

Oil pastels

Pastels

Pastels are sticks of pigment with chalk, weakly bound with gum. They are available commercially in three main grades, hard, medium and soft, the latter being the most traditional and popular. They have a similar texture to natural chalk and work well on toned, textured and specially coated papers.

The soft grey-blue lines of silverpoint oxidize to a warmer brown colour.

Silverpoint

Silverpoint is a unique and delicate drawing medium that involves a very thin piece of silver wire secured in a silverpoint holder (*below*) or a clutch pencil. Prepare the paper with two coats of Zinc White gouache paint and let it dry thoroughly before drawing on it.

Wax crayons

Wax crayons

Pigments bound in wax have been used as art materials for centuries. The better quality crayons give a dense, water-resistant mark that works well with watercolour washes.

WET MATERIALS

PEN AND INK and brush and wash are the main wet materials used for figure drawing. As artists know, there is a big difference between working with easily erasable dry materials like pencil and working with the more immediately permanent mark-makers such as pen and ink. It is, of course, quite common for artists to sketch an image roughly in pencil before drawing over the lines in pen or brush and wash. But it can be more exciting and more absorbing to work directly in these materials, knowing that once you have made your mark you are committed to it.

Pen and ink

A pen and ink drawing often has a clarity that sums up the figure in a concise, immediate way. Black or white inks are generally pigmented and permanent. Coloured inks are often based on soluble dyes and can be impermanent. If you don't want your drawings to fade, check to see if the ink is pigmented.

Brush and ink

Use the flexibility of a fine, soft brush, such as a sable, dipped in Indian ink to capture the broad outlines of the standing figure. You will soon learn to adjust the quality of line by finely adjusting the pressure on the paper and the speed at which you make your marks.

Nibs

Artists can choose from a huge variety of pens, including traditional dip pens with steel drawing nibs. These have a flexibility that allows you to modify the width of a line as you draw. Other nibs include the script or calligraphic varieties, which offer interesting possibilities for figure drawing.

Chinese brush

Size 3 sable brush

Drawing with paint

Acrylic paint or gouache can be diluted and used like watercolour to make brush and wash drawings. It has the advantage that it can be overpainted freely once dry, without risk of dissolving the paint film beneath. Make sure you wash the brushes thoroughly after use.

Acrylic paints

Watercolour

Watercolour can be used with a brush as a drawing medium similar to brush and diluted ink. Use one or several colours to suggest the broad lines of a figure. One great advantage over other paints is its portability.

Washes

Watercolour is often applied in washes over pencil, pen or crayon lines. Washes add colour to a drawing and can be vital to the mood of a work.

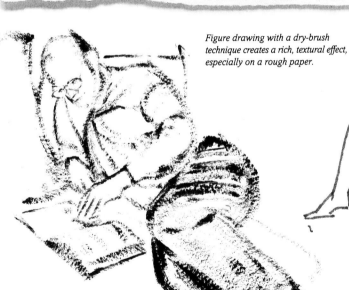

Figure drawing with a dry-brush technique creates a rich, textural effect, especially on a rough paper.

Monochromatic studies

This monochromatic study, made rapidly in brush and watercolour, shows a group of figures leaning forward into the wind as they walk across a beach. A series of swift, expressive brushstrokes capture the way the shapes of the figures are modified by the effect of the wind on their loose clothing.

Rollerball pen

Rollerball pens are designed to be used at various angles and they are extremely comfortable to work with, though the ink may not be permanent. Like fibre-tipped pens, Rollerball pens come in a variety of colours and give loose, lively marks that can capture a pose and mood economically. The immediacy of this drawing, made in just a couple of minutes, shows a direct and honest response to the model (*see* pp. 38-39).

Rollerball pen

Technical pen

Sketch pen

Dry-brush drawing

If you are drawing the figure using paint, it is not necessary to use washes every time. An alternative technique is dry-brush drawing, which produces good half-tone effects. Fill your brush with acrylic or oil colour of tube consistency, wipe off the paint with a clean towel or tissue and draw the figure using a scumbling technique (*see* pp. 70-71). The same approach can be used with diluted paint. In all kinds of dry-brush drawing, the texture of the paper is an essential feature.

Pens

There are technical pens with tubular nibs of varying fixed width and many are ideal for direct, rapid figure drawing. They draw consistently even lines that are easy to control, allowing you to chart your way around the figure with great precision. Sketch pens have flexible steel nibs designed specifically for drawing, but they often take a little getting used to.

Paper

IF YOU ARE USED to drawing on regular white cartridge paper, you will have no sense of how widely varying types of paper can affect every aspect of your style and technique. Drawing is not about superimposing the medium on a bland or neutral surface, but about the physical interaction between the medium and the support. A pencil can slide along a smooth surface or bump around in the peaks and troughs of a rough one. Absorbent paper gives one effect, well-sized paper another, while toned papers offer quite different results.

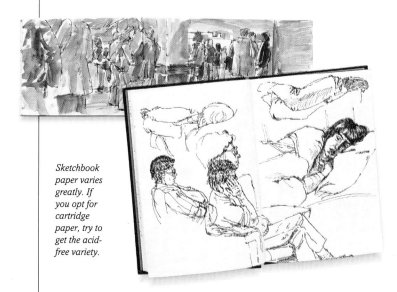

Sketchbook paper varies greatly. If you opt for cartridge paper, try to get the acid-free variety.

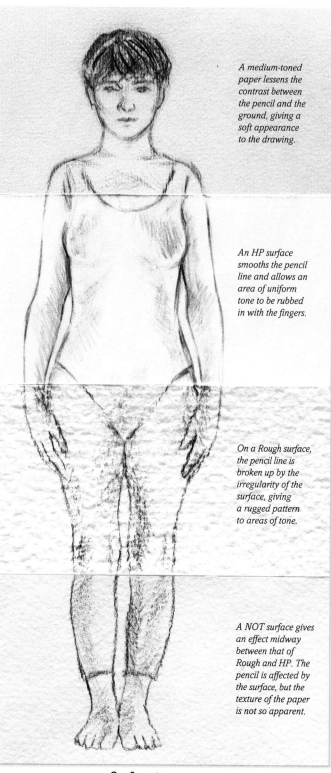

A medium-toned paper lessens the contrast between the pencil and the ground, giving a soft appearance to the drawing.

An HP surface smooths the pencil line and allows an area of uniform tone to be rubbed in with the fingers.

On a Rough surface, the pencil line is broken up by the irregularity of the surface, giving a rugged pattern to areas of tone.

A NOT surface gives an effect midway between that of Rough and HP. The pencil is affected by the surface, but the texture of the paper is not so apparent.

Weight

Good quality watercolour paper is excellent for figure drawing. It is made from cotton linters or fibres, pulped, internally sized and drawn up over a cylinder mould. It is then pressed, dried and surface-sized. The speed of the mould machine and the ratio of fibre to water determines the weight of the paper. Paper comes in different weights, the three main ones being 90lb (185gsm), 140lb (300gsm) and 300lb (640gsm). If you want to work vigorously into the surface, then the stiffer papers are the ones to use.

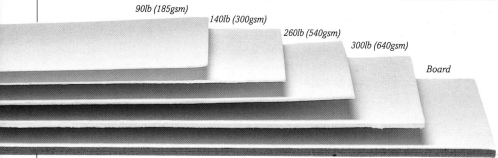

90lb (185gsm)

140lb (300gsm)

260lb (540gsm)

300lb (640gsm)

Board

Surface types

The three main types of surface in good quality Western watercolour and drawing papers are HP (Hot-pressed), NOT or CP (Cold-pressed) and Rough. An HP surface is smooth, a NOT surface has a fine-grain finish and a Rough surface has a more rugged texture. Any drawing medium will perform differently on each type of surface. Charcoal will skid around on an HP surface but create chunky half-tone effects on a Rough one.

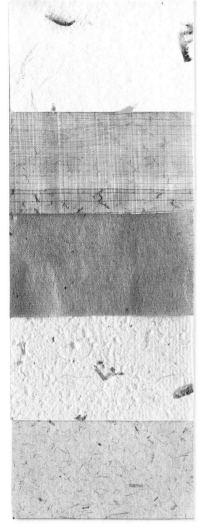

On sized paper the colour sits on the surface.

Ink or watercolour soaks into the unsized paper.

Oriental papers

A wide range of Oriental papers is now freely available. They are generally more suitable for brush drawing than for work with dry materials because they are usually thinner and more absorbent than Western papers. Oriental papers are made from a variety of vegetable fibres, combined with vegetable sizes and dyes, and the fibres often show in the texture of the paper.

Absorbency

If you take a brush well charged with watercolour or ink and make a stroke on a well-sized paper, the colour will sit in a puddle on the surface and the water will evaporate. If you make the same stroke on a thinly sized or unsized paper, such as blotting paper or certain Oriental papers, it will instantly be absorbed and the pigment will seem to become part of the fabric of the paper itself.

Textures and tones

A range of textures and tones can be seen in these commercially available papers suitable for figure drawing. On the whole, artists tend to prefer white or off-white papers to the toned variety. But toned paper gives scope for the kind of figure work that could not be made on white paper. In the past, artists used toned papers to great effect, drawing the figures in charcoal on a blue-grey paper, for instance, and then adding the light tones and highlights with white chalk or watercolour. This gives a three-dimensional effect that could not be obtained on white paper without considerably more work.

Experiment with different tones and surfaces to discover the papers that suit you best.

A smooth cool brown paper works well when drawing "à trois couleurs" (with orange-red, black and white).

Blue-grey toned paper has traditionally been popular for drawings with charcoal and chalk.

The surface textures of paper within the HP, NOT and Rough classifications vary from one manufacturer to another.

A deep-toned paper provides an underlying matrix of colour for well-worked pastel drawing.

BASIC TECHNIQUES

THERE ARE A NUMBER of basic line and tone techniques that you can use to describe the shape and model the form of a figure. These include simple outline drawings in pencil or pen, directional shading or hatching, curved linear shading that follows the contours of particular parts of the body and cross-hatched shading of various kinds. You can also use rubbed or smudged shading techniques, including drawing with a paper stump and working with an eraser. It is worth exploring all of these methods in a series of studies. Each one will produce a different effect according to your style and the material you choose to use.

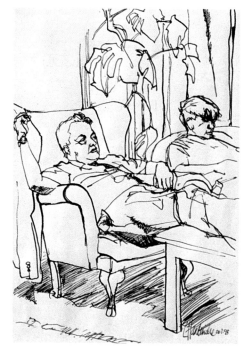

Pen line
A pen gives a clarity to an outline drawing that would be difficult to achieve with another medium. Direct line drawing with a pen can be exhilarating and challenging, as you only have one chance to get it right.

Pencil line
There is a refreshing economy to a discipline that requires only a pencil and paper. Keep the lead sharp and you will get a crisp, fine line; let it become blunt and the line will be softer and less precise.

Quality of line
How you decide to use the pencil will depend very much on the nature of the pose. The easy nonchalance of this pose lends itself well to the intimacy of the pale pencil line. Though this is only a quick sketch, the artist has paid close attention to details such as the fingers.

Contour shading
The forms that make up the human figure are rounded and artists have found that curved parallel lines can effectively define the contours of the body or drapery. Michelangelo and Van Gogh are among those who have mastered this shading technique.

Directional shading

Shading can provide a solid overall structure from which a figure emerges. In this pencil study, the vigorous directional shading of the background gives weight and bulk to the duffle-coated sitter (*right*). The direction of the shading is adjusted to the line of the arm or the curve of the coat and the shading is reinforced by a strong outline definition of the shapes. This kind of shading interacts with the surface of the paper in an expressive way and the texture of the laid paper is revealed.

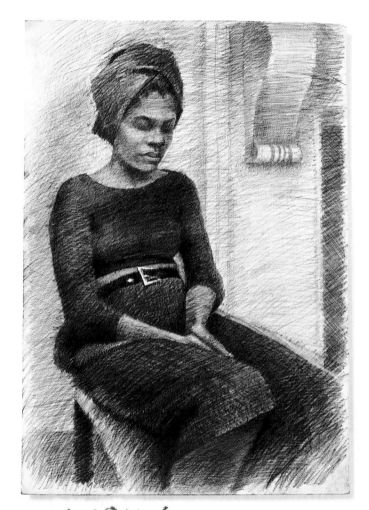

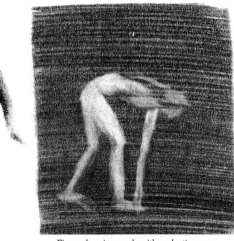

Figure drawing made with a plastic eraser.

Stump drawing

A paper stump or torchon is generally used to soften areas of tone, but it can equally well be used to make a complete figure drawing. Rub some Conté crayon on to the stump and apply this to the paper to create your figure.

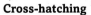

Cross-hatching

The principle of cross-hatching is that if the artist applies one series of parallel lines at right angles over another, the tone will be twice as dark in that area. It is a common method of giving dimensionality to forms and has been used with careful accuracy on the clothing in this drawing (*above*).

Eraser drawing

An eraser is an important tool for adjusting line and tone and for picking out highlights. It is possible to make a complete figure drawing with an eraser by rubbing the image out of an evenly shaded area (*above right*).

GETTING STARTED: 2D

IF YOU ARE COMPLETELY NEW to figure drawing and the idea of sketching a real person is intimidating, you can begin by making simple copies from figures in photographs or paintings. This is a helpful way to start, because you are looking at images that are already two-dimensional and it is easier to get an idea of the basic shapes involved. Draw directly, without worrying too much about accuracy or detail. Another useful exercise is to make simple outline tracings of figures in photographs. These can be used for transferring the images to your sketchbook or as guides for freehand studies.

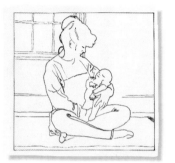

1 ▲ When tracing a photograph, decide which are the most important lines for defining the figure.

2 ▲ Carefully trace the lines of the figure using a sharp pencil or a black fibre-tipped pen. You need only include the broad shapes of the composition.

3 ▷ The tracing provides an accurate framework for a simple pencil drawing in which the gentleness of the pose is emphasized by tonal shading. This creates a soft silhouette effect, as if echoing the protective nature of the relationship between mother and baby.

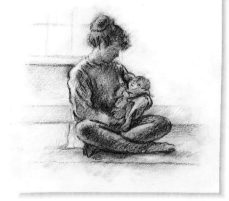

The traced lines provide a framework for the drawing.

Postcards
Postcards of artworks are an excellent source of two-dimensional reference. This oil painting, *Friends*, by Norman Hepple RA, has been copied freehand in soft pencil.

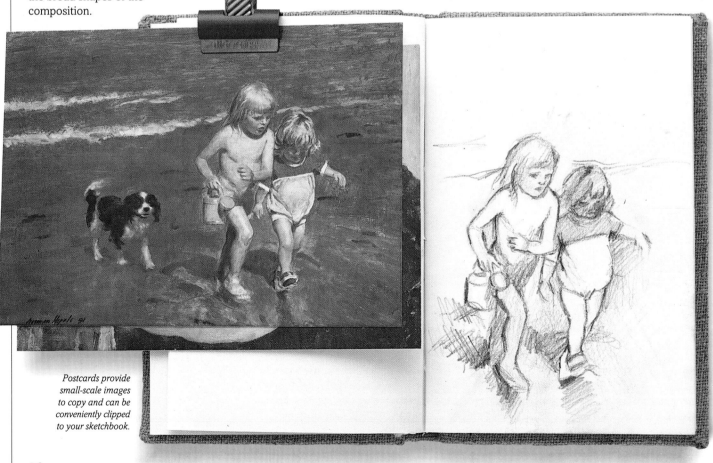

Postcards provide small-scale images to copy and can be conveniently clipped to your sketchbook.

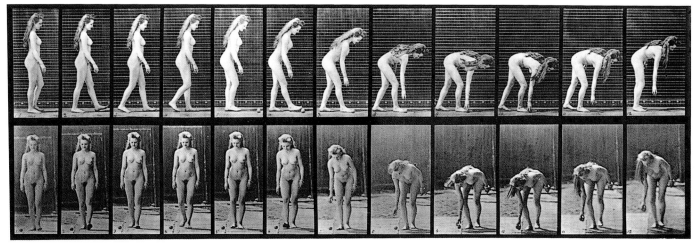

Figures in motion

Images by the pioneering photographer Eadweard Muybridge, such as these from *Animal Locomotion*, published in 1887, are the earliest and one of the best sources of reference for sketching the figure in motion. These studies, printed the size they were drawn, have all been sketched directly in fibre-tipped pen, pencil or brush and ink, with no modifications during or after drawing.

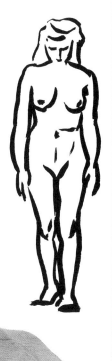

Brush and ink

Create drawings in brush and ink (*right*) by looking carefully from photograph to sketchpad. Gradually make a series of brushstrokes that define the contours of the figure.

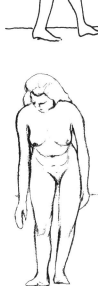

Eraser drawing

When you have made a series of small drawings in pencil, make one in which you refine the quality of the pencil line with an eraser (*left*). Plastic erasers are usually too big to make the finer adjustments to such small drawings, so cut off a corner and use the sharp edge. Alternatively, a putty rubber can be moulded into a tiny point for working on very small studies.

Small-scale work

The size of the hand gives a good sense of the scale of these drawings. When you work on such a small scale, you will notice that your drawings often give a much clearer focus to the figure than a similar-sized tracing might. The brain seems to enhance the image received by the eye and direct the hand to produce a sketch of great clarity. By making a series of sketches, you will quickly improve your understanding of how the figure moves.

GETTING STARTED: 3D

SMALL-SCALE THREE-DIMENSIONAL objects, such as toy soldiers and dolls, make excellent preliminary models for figure drawing from life. Jointed wooden lay figures are ideal for making drawings of approximate figure shapes; the reduced scale and simplified construction make them more accessible than real life sitters. Draw the figures the same size as the originals and then larger than life, using a sharpened pencil or a Conté crayon. Once you feel confident that your studies are reasonably accurate, move on to more complex three-dimensional subjects, such as small-scale figures and statues in museums.

Toy figures
Tiny plastic figures like toy soldiers are fun to draw and are generally made to scale. Draw them against a plain white background.

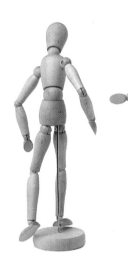

Lay figures
Jointed wooden lay figures can be manipulated to show numerous positions and movements. They enable you to concentrate on form without being distracted by detail or texture.

Conté studies
Use a square Conté crayon to make drawings directly from the lay figure. The sharp corners of the crayon can be used for the lines that define the shape, while the broad edges create the soft tones that give dimensionality to the object.

Pose and mood
These drawings show how it is possible to create a credible context or mood in your studies, even with such a simple, diagrammatic device as the lay figure. Mood is directly related to pose: the figure on the left looks down with care and concern at whatever he or she is holding or tending; in the central pose, the arms are raised and the head thrown back in celebration or exhortation; on the right, the figure scampers off the page with a sense of great energy.

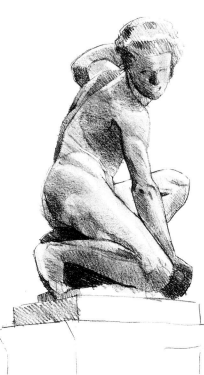

Drawing from sculpture

Visit local museums and galleries and draw from statues in bronze, stone, terracotta or wax. Begin with the small ones; these will be much easier to take in at a glance. Concentrate on the whole figure and simplify its component parts as you make simple studies. Lightly sketch in the whole shape and then work over it in more detail.

Choosing a viewpoint

Try to find an interesting angle from which to draw the statue. Here, the twist in the trunk, the straightened right arm and angle of the head give a sense of tension and movement that is echoed in the quality of line and direction of the tonal shading.

Weight and balance

Try to give a sense of how the figure is placed and where the bodyweight is concentrated. Here, the figure's right leg is solidly planted while the left one is raised. This pushes out the right hip, which becomes a key element in the structure of the drawing.

Expressive materials

Use a drawing material that seems to suit the nature of the statue. A piece of charcoal or crayon, used deftly, will give a soft tonal line that can echo the sensitivity of the sculpture. Here, the quality of the pencil line perfectly suits the grace of the subject (*right*).

Museum work

Do not be afraid of working in public – it is unlikely that you will be surrounded by onlookers. In fact, in many of the larger museums you will be able to tuck yourself away in a quiet gallery and sketch in peace. When you move on to larger statues, use charcoal to capture the drama of the work. Here, the deep velvety tones of charcoal give a good sense of the smooth, pale stone emerging from the shadows. Use your fingers to blend the tones and soften the edges, and use an eraser to create clean, bright highlights.

GALLERY OF SKETCHBOOKS

THE DIARIES AND SKETCHBOOKS of artists are frequently rich with images of the human figure. These can be refreshingly immediate observations of people going about their work and play, or relaxed and intimate images of family and friends, such as those shown here by Nahem Shoa and Sue Sareen. Sketchbooks may include studies made from paintings by other artists, exploratory compositions for larger-scale works, or absent-minded doodles that turn into imaginary figures. Above all, the sketchbook or the scrap of paper is the arena in which the artist's imagination is given free rein, and it is the place where most ideas happen. Often, it is when we look through an artist's sketchbook, rather than at a finished work, that we come closest to his or her personality.

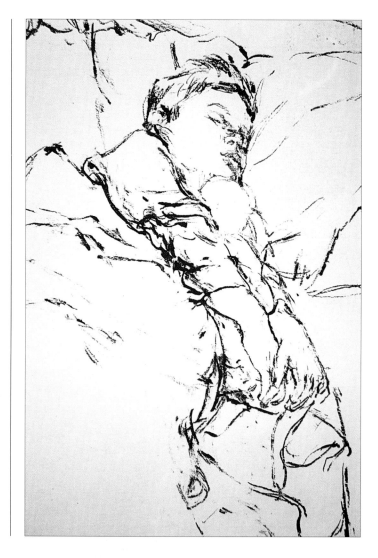

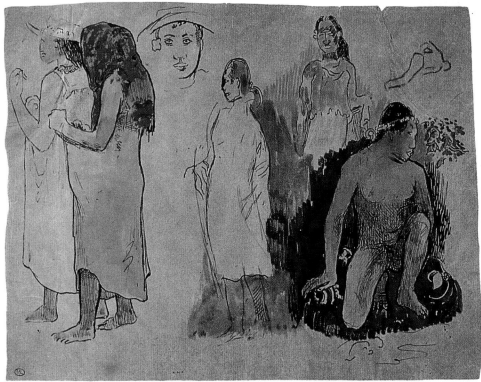

Sue Sareen, *Seth,* *51 x 40.5 cm (20 x 16 in)*
This beautifully observed charcoal sketch absolutely captures the spirit of the young boy, asleep and completely relaxed, with his head cradled softly in the pillow, his arms outstretched and his fingers curled snugly over one another. The concentration of the artist is palpable as one imagines her silent focus during the drawing process. There is a tenderness in the approach that creates a magical atmosphere.

Paul Gauguin, *Noa Noa (Sketchbook) Page, c.*1893, *19.5 x 25.5 cm (7³/₄ x 10 in)*
This page from Gauguin's travel sketchbook demonstrates perfectly the different aspects of visual research that make the artist's sketchbook a treasure trove of ideas. There is a disarming freshness about the rapidly made drawings, and we have a sense of being present with the artist as he experiments with colour washes and works up a figure to the point where it can be incorporated into his paintings.

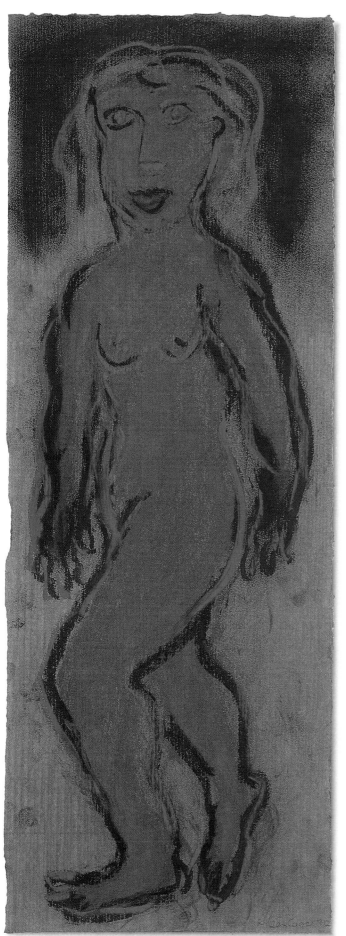

Nahem Shoa,
Sketchbook Page,
12.5 x 19.5 cm (5 x 7³/₄ in)
Occasionally, you will come across a sketchbook page in which genuine observation combines with real human understanding, technical fluency and compositional skill to produce an image of great depth and insight. This line drawing of the artist's grandmother is such an image. He has given only as much information as is absolutely necessary to create a powerful sense of the sitter.

Eileen Cooper,
Young Woman,
66.7 x 24.2 cm (26¹/₄ x 9¹/₂ in)
The vitality and immediacy of this nude study stem from the dusty rich hues of the pastel medium and from the bold, open style of the drawing. The warmth of the body colour in rich orange-brown is emphasized by the cooler tone of the paper and by the almost iridescent violet outline of the figure.

Pablo Picasso,
Sketchbook No. 76,
Page 37, 1922,
15.5 x 11.5 cm (6 x 4¹/₂ in)
This sketchbook page shows how a few economical pencil strokes and some smudges of colour can fill the page with a monumental and effectively three-dimensional image. The red curtains, pushing gently against the figures, enhance the intimacy of this family scene.

21

ANATOMY

THESE DAYS, IT IS UNCOMMON for an artist to undertake a rigorous training in anatomy, but the more you learn about the structure and mechanics of the human body, the more easily you will be able to recognize and make sense of what you see when you are drawing from life. Look at the works of artists like Leonardo da Vinci or Michelangelo, who had a deep understanding of anatomy, and you'll see that their drawings and paintings of figures are particularly convincing. In recent times, people have become more knowledgeable about their bodies and more concerned about keeping them in good shape. As a result, there is a great deal of accessible information that can be helpful to artists, including clear visual guides to anatomy, accurate plastic figures and computer models that enable us to study structure and form in great detail.

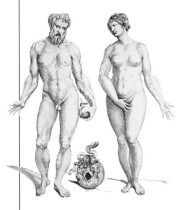

Early anatomy
In his monumental illustrated text, *De humani corporis fabricia*, the 16th-century Flemish anatomist Vesalius challenged traditional theories about the human body.

The skeleton

The skeleton is the jointed internal armature of rigid bones and cartilage that supports the body, protects the vital organs and, in conjunction with the muscles, enables the body to move. Men and women have similar skeletons, but the female rib-cage is smaller and shorter than that of the male and the female pelvis and sacrum wider. One practical way to study the underlying structure of the body is to get hold of a jointed plastic model of a skeleton and make drawings of it in different positions and from a variety of angles. This will help you envisage how the skeleton is functioning when you draw a model from life.

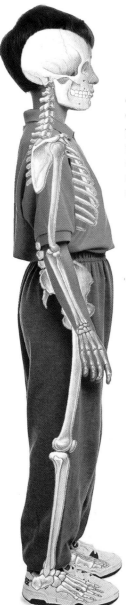

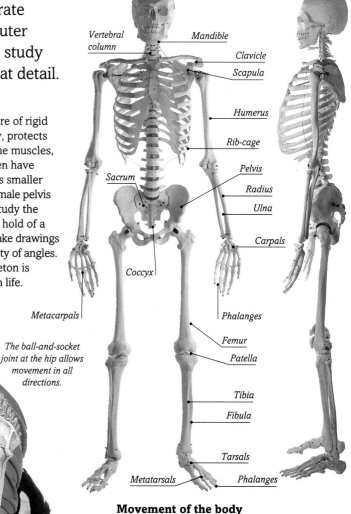

Skull
Vertebral column
Mandible
Clavicle
Scapula
Humerus
Rib-cage
Sacrum
Pelvis
Radius
Ulna
Carpals
Coccyx
Metacarpals
Phalanges
Femur
Patella
Tibia
Fibula
Tarsals
Metatarsals
Phalanges

The ball-and-socket joint at the hip allows movement in all directions.

The elbow hinge joint is capable of flexion and extension.

Movement of the body

Get to know the various kinds of movable joints in the body. Hinge joints allow movement to and fro in one plane only, while ball-and-socket joints, such as those in the hip and shoulder, facilitate movement in all directions. Pivot joints, such as those in the radius and ulna bones of the forearm, allow rotation along the bone's length.

Muscular structure

Attached to bones and cartilage either directly or by means of tendons, muscles produce movement by contraction. There is a great difference in the surface appearance of a muscle when it is in tension and when it is relaxed. Males and females have similar muscles, but men are generally more muscular than women. Refer to specialist publications or to plastic models (*right*) to identify the main muscle forms. When you come back to the life model you will be surprised how much your research has helped your understanding.

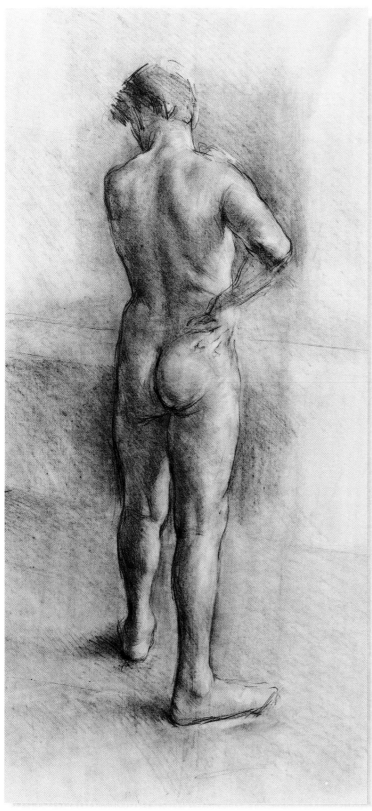

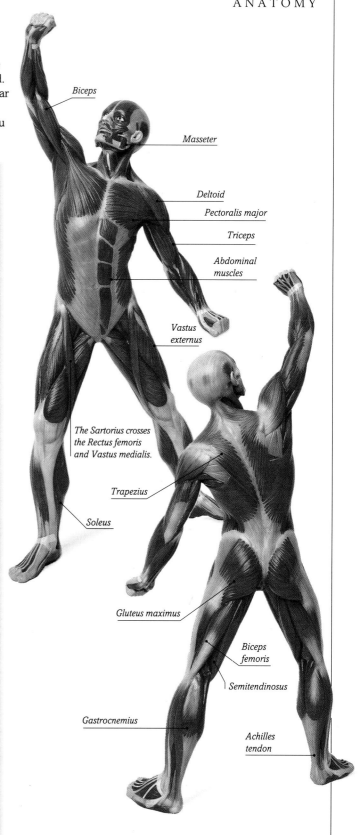

Biceps

Masseter

Deltoid

Pectoralis major

Triceps

Abdominal muscles

Vastus externus

The Sartorius crosses the Rectus femoris and Vastus medialis.

Trapezius

Soleus

Gluteus maximus

Biceps femoris

Semitendinosus

Gastrocnemius

Achilles tendon

Drawing muscle forms

Most people do not have perfectly toned bodies, but a carefully observed drawing based on a sound grasp of anatomy will still indicate the underlying framework and the main areas of muscle form. In this pencil drawing, a combination of rubbing and contour shading has been used to give a rounded quality to the muscle forms. It indicates a clear light source and allows us to read the image as an authentic example of human biology.

PROPORTION

Use the proportions of the chair to help you draw a seated figure.

I N FIGURE DRAWING, artists are acutely conscious of what they perceive as the correct relationship of the parts to the whole. So when you see that you have drawn the head, for instance, too big or too small for the body, the result seems particularly unsatisfactory. The best way to get an accurate representation of the proportions of a figure is to hold a pencil at arm's length and use it as a measuring device to establish the relative distances between parts of the body. Remember that human beings do, of course, come in all shapes and sizes.

The female shape differs considerably from that of the male; the waist is narrower and the hips broader.

Basic proportion

Leonardo da Vinci demonstrated that with legs spread and arms raised, so that the middle fingers are on a level with the top of the head, the navel of an adult man is the centre of a circle and the fingertips and toes are at its circumference.

Proportions of the head

The distance between the chin and the nose, like that between the eyebrows and the hair-line, is approximately equal to the height of the ear and makes up about a third of the face.

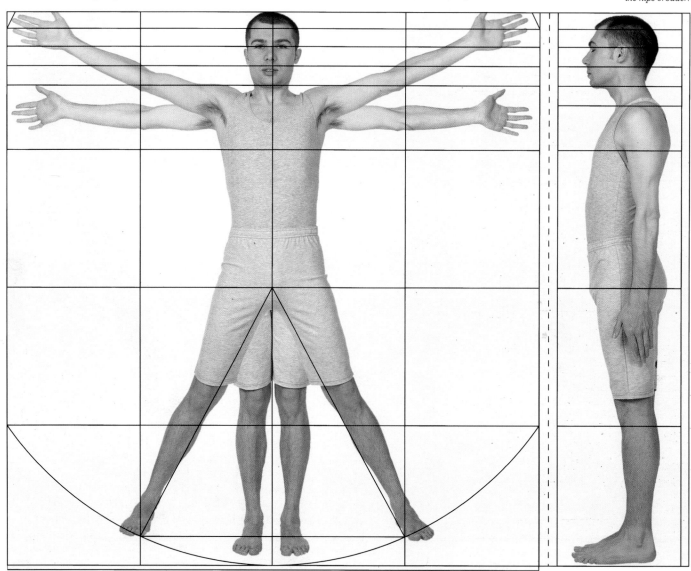

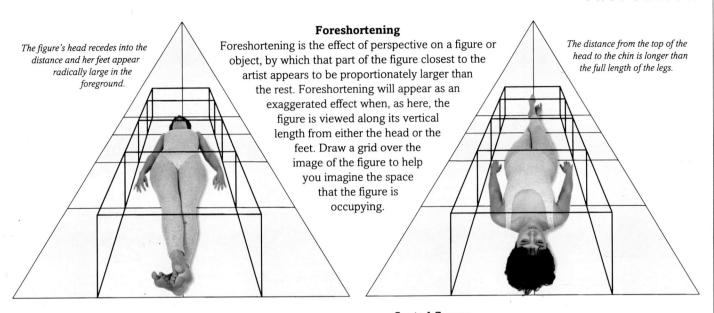

The figure's head recedes into the distance and her feet appear radically large in the foreground.

Foreshortening

Foreshortening is the effect of perspective on a figure or object, by which that part of the figure closest to the artist appears to be proportionately larger than the rest. Foreshortening will appear as an exaggerated effect when, as here, the figure is viewed along its vertical length from either the head or the feet. Draw a grid over the image of the figure to help you imagine the space that the figure is occupying.

The distance from the top of the head to the chin is longer than the full length of the legs.

Unique factors

When faced with radical changes in proportion, it is difficult to forget what you actually know about the real sizes of the body parts. Use photographs and the drawings of other artists to help you see the figure in terms of a simplified outline.

Seated figures

A prop such as a chair provides a useful structure against which the relative proportions of a seated figure can be measured. Here, there is some foreshortening, with the model's buttocks closest to the viewer and her body leaning into the background (*left*). Perspective lines on the floor guide the artist and emphasize the foreshortening in the finished work.

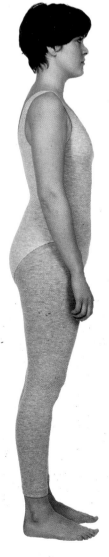

Figures in profile

Studying the human body in profile is a very helpful exercise. With only one arm and one leg visible, the structure of the standing figure is more accessible and you can chart the full length of the figure in a series of points of focus.

Viewpoints

You can use your viewpoint as a device for simplifying the structure of a seated figure. The relatively high angle from which the artist has viewed his sitter shows how the rounded planes of the figure echo the flat planes of the chair. The upper legs come forward parallel to the floor, echoing the chair seat, while the lower legs are positioned vertically, like the chair legs.

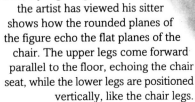

HEADS, HANDS & FEET

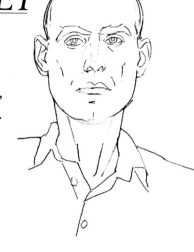

ONE OF THE BEST ways of learning how the body fits together is to look very closely at its separate parts. Some people have great difficulty drawing hands, which are often fudged or glossed over in figure work. But if you concentrate on these complex and infinitely variable appendages, you will soon find ways of translating what you see into a pictorial language that reflects your growing understanding of how they work. Heads, faces and feet warrant an equally close study.

The mobile clarity of the pencil line over the smudged areas of tone allows the head and clasped hands to emerge with a firm and rugged dimensionality.

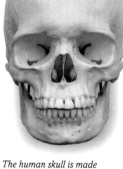

The human skull is made up of 22 plate-like bones, including eight cranial and 12 facial bones.

Sharp pencil lines and good tonal work capture the solid form of the head and neck.

The skull

Compare the shape of the skull to the full-face drawings (*left, above right*) and you will see how clearly the physiognomy relates to the structure beneath the surface. Both drawings are drawn slightly from below, which increases the apparent width of the jaw and reduces that of the cranium.

Linear portrait

A simple line drawing, made intensively and rapidly from life, gives a clear sense of the solid bones beneath the skin, even though it is spare and economical in its approach.

Movement of the head

It is important to recognize the kinds of factors that affect our reading of a head. If you draw a head full-face and with the eyes closed, the character, though seen clearly, will seem to exist in a dream world of his or her own. Incline the head slightly to one side and there is an air of resignation. The expressive adaptability of the movement of the head can be seen in these four images (*below*).

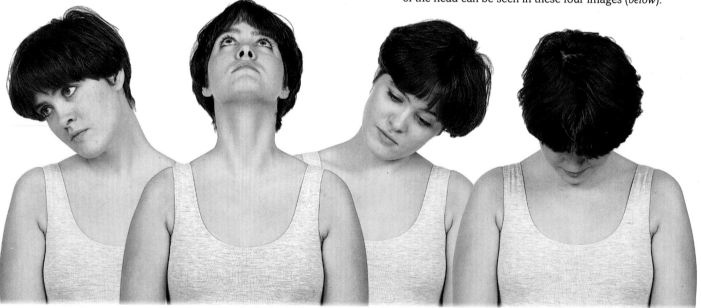

The long, elegant line of the neck is emphasized as the head leans to the side.

When the head is tilted back, the features are seen from a more unusual perspective.

With the head to one side and the eyes lowered, the face is particularly expressive.

When the head is tilted forward, the features appear compressed.

Hands

Like the head, the surface of the hands reveals the structure of the skeleton beneath, especially on the outer side. The bones of the fingers are the phalanges, three in each finger and two in the thumb. These are connected to the metacarpals, the heads of which can be seen as knuckles where the fingers flex. Eight small carpal bones give the wrist great flexibility and strength. Make simple line drawings by placing your own hand on a sheet of paper and tracing around the edges. Next, make studies in which you carefully map out the various bony protuberances of your hand.

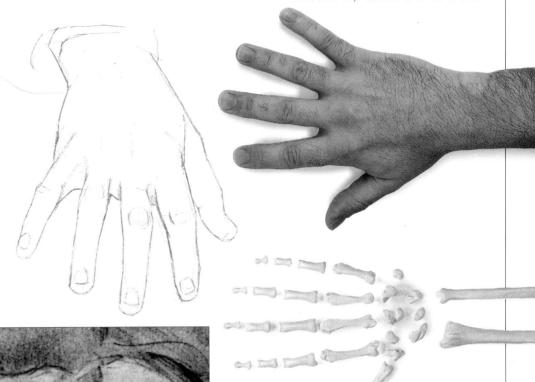

Tonal study

There is an infinite range of positions in which the hands can be drawn. Very often in a pose the fingers are interlocked. This can look extremely complex, but if you bear in mind the straightforward structure of the skeleton beneath, you should begin to find the pose easier to draw. Practise sketching pairs of hands using charcoal or soft pencil. In this tonal study, the long tendons of the wrist are clear through the skin and the proportions of the fingers have been accurately observed.

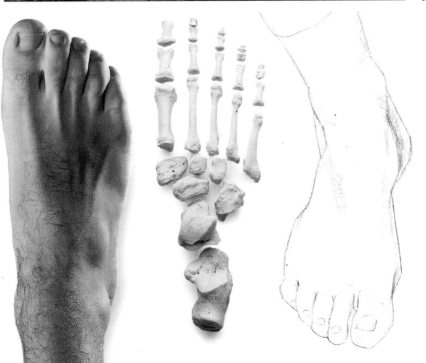

Feet

The foot skeleton is similar to the hand skeleton in that four of the toes have three phalanges each, like the fingers, and the big toe has two, like the thumb. These are connected to the metatarsal bones, the equivalent of the metacarpals in the hand. The phalanges of the toes are very small compared to the other bones. The foot takes the weight of the whole body and most of its bones are strong and heavy.

GALLERY OF ANATOMICAL STUDIES

A LONG TRADITION of anatomical drawing in medicine, combined with a natural curiosity to discover what lies beneath the skin, has prompted many artists to make detailed anatomical studies for themselves. Leonardo da Vinci dissected ten bodies in order to satisfy his desire for anatomical truth. Today, artists tend not to go to such lengths, especially since good visual information is so easily obtainable (*see* pp. 22-23). However, focusing on individual parts of the body, such as the arms and hands, remains a popular element of figure drawing and artists have perfected techniques to define form in the most accurate and striking ways.

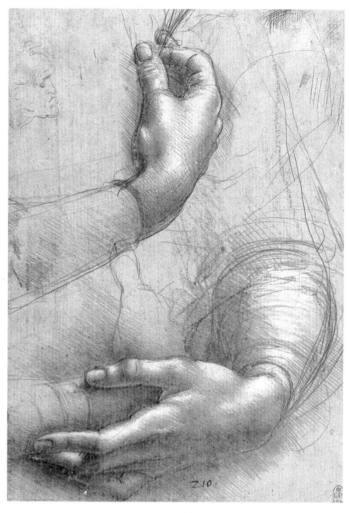

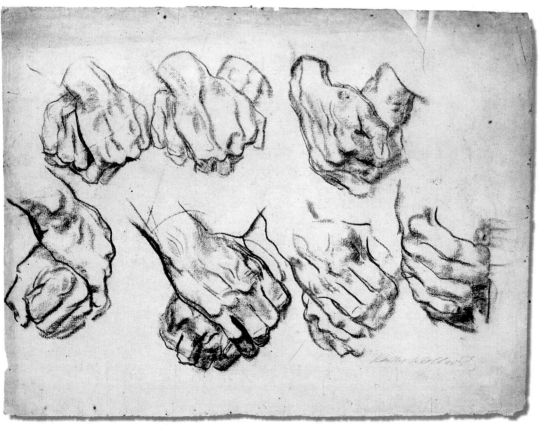

Leonardo da Vinci, *Studies of Arms and Hands*, **1474,** *21.4 x 15 cm (8¹/₂ x 6 in) Leonardo's technique involves drawing the image on to a buff ground, specially prepared for metalpoint, and heightening the lights with white. This gives the hands in this study a grace and dimensionality that would have been difficult to achieve so concisely on a white ground.*

Käthe Kollwitz, *Seven Studies of Hands, c.1925,* *56.5 x 76 cm (22¹/₄ x 30 in) Kollwitz's charcoal drawings are not only fine anatomical studies, including just enough information in line and tone to give a complete sense of the form, but they also generate a powerful emotional intensity. The artist uses the image of one hand tightening over the other as a device to reflect some larger human struggle.*

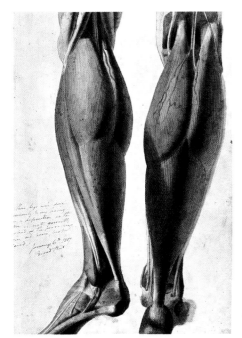

Benjamin Robert Haydon RA, *Anatomical Drawing of Two Legs,* **1807,** *46 x 32.3 cm (18 x 12³/₄ in)* This highly detailed pen and wash study by Benjamin Robert Haydon RA analyses the lower leg muscles, or Gastrocnemius. Meticulous hatching defines the forms of the slightly larger medial head of the inner calf and the lateral head beside it. The delicate line of the pen charts the Gastrocnemius tendon as it runs down the ankle to form the Achilles tendon at the heel.

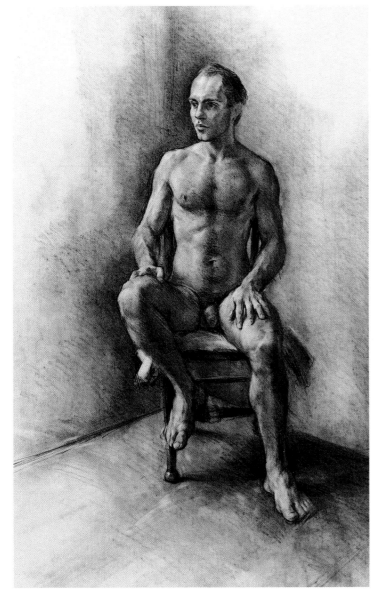

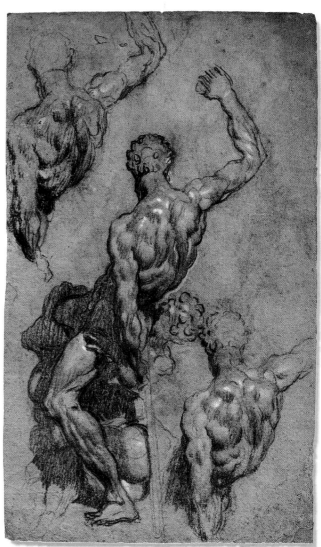

Jacopo Tintoretto, *Studies after Michelangelo's "Samson and the Philistines",* **c.1545-55,** *45.2 x 27.3 cm (17³/₄ x 10³/₄ in)* Tintoretto greatly admired Michelangelo's sculptures and worked from clay copies to practise his anatomical drawing. He was said to have lit the models dramatically in his studio in order to emphasize the highlights and shadows. Here, he has worked on grey-green paper, using charcoal to define the form. A contour shading technique is used for the musculature and white body colour is added for the highlights.

Neale Worley, *Italian Male Nude,* *63 x 45 cm (24³/₄ x 17³/₄ in)* This is a well-observed and carefully drawn image by an artist who gives a complete sense of the whole figure without sacrificing the drawing's liveliness. In many areas, the texture of the skin is achieved by rubbing the soft pencil into the paper with the fingers. Highlights are then picked out of these blended areas with an eraser.

In this detail, the deft linear work and well-observed shading create a convincing sense of anatomical form.

29

DRAWING FROM LIFE

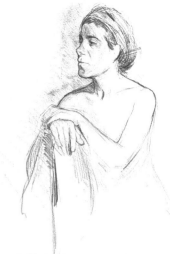

THE ATMOSPHERE OF INTENSE concentration that usually accompanies figure drawing from life marks it out as unique among art activities. You might begin at home with a member of your family or a friend as your sitter. Encourage the sitter to find a comfortable pose and to take regular breaks. When possible, draw alongside other artists; this will help your concentration and may even set up a little positive rivalry that informs your own techniques and inspires you to make better drawings. Many local colleges offer evening life drawing classes and these can be an excellent weekly focus for figure drawing. The models are used to a more demanding role and can be relied on for their professionalism.

In life drawing sessions, you can concentrate on just one part of the figure, such as the head and shoulders.

Nude figures
The nude figure is an excellent subject for drawing in colour. This study is deliberately highly chromatic with its red, orange, purple and green colouring. The almost shocking combination of colours powerfully captures the bold and present sense of the life model.

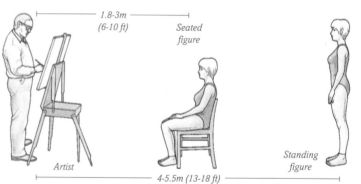

1.8-3m (6-10 ft)

Seated figure

Artist

Standing figure

4-5.5m (13-18 ft)

Ideal distances
Establish how far away from your sitter you should be in order to be able to take in the whole pose comfortably. For a full-length standing figure you should be about 4-5.5 metres (13-18 feet) away and 1.8-3 metres (6-10 feet) away from a half-length or seated figure.

Life drawing classes
The life room at the Royal Academy of Arts, London, gives a sense of the spell-binding concentration inspired by work of this kind. The students are positioned about four metres (13 feet) from the model and north light from the high windows behind them gives an ideal natural and even illumination.

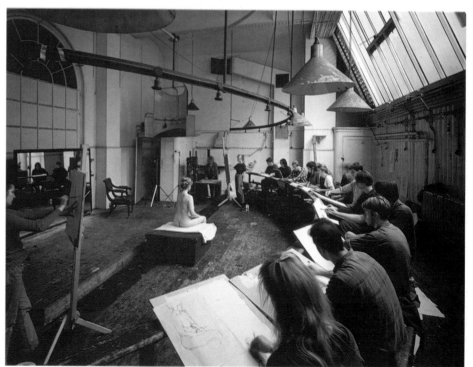

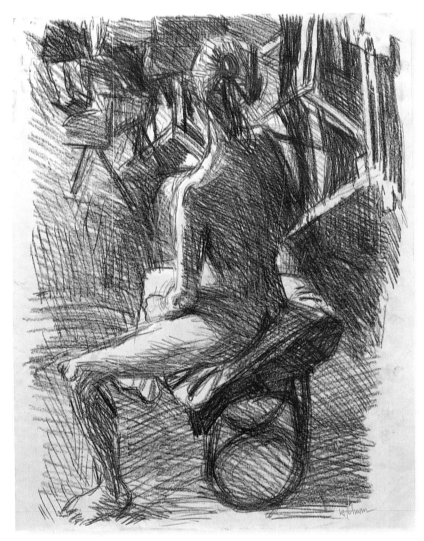

Lighting the figure

Try different variations in lighting so that you can experiment with the tonality of your drawing. In hard, direct light, the contrasts between the light and dark tones are exaggerated, while in indirect, subdued lighting conditions, there is a softer, more overall quality to the tonal variation. Here, the edge of the model's neck is illuminated by bright light which travels across the shoulder and down the upper arm to the thighs and feet.

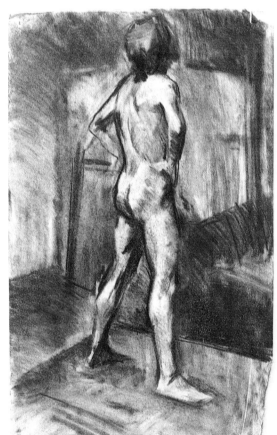

Expressive materials

Select your material according to the effect you want to create. Charcoal is a particularly expressive medium for figure drawing from life. It responds to the texture of the paper, establishing an intimate link with its fibres where it is rubbed in to create tone with fingers or a paper stump. It can also define contour and outline in rich, velvety strokes. In this solid, standing pose (*above*), with the legs set apart and the hands on hips, the charcoal is exploited for just these qualities.

Unusual poses

An unusual pose can give a special quality to an image. With hands clasping the left leg just above the knee, this pose has an urgency and intensity. It is not an easy position to sustain and one senses the artist's need to get it down on paper as rapidly as possible.

Reclining figures

Use pure pencil line in all its classic refinement to express the languid pose of the model reclining. There is a remarkable clarity to the hard pencil line when it is used in this unfussy way. Such drawings often work best when the single defining line is uncluttered by repetition. You can achieve this either by drawing the line in one go, or by erasing all previous attempts when re-working it. Bear in mind how very different the appearance of the line will be according to the grade and type of pencil used.

ACCURATE LINE DRAWING

THERE ARE A NUMBER OF ELEMENTS that are basic to drawing technique and although they generally work together within a drawing, it helps to study them separately. In your first few drawings from life, concentrate on defining the figure using only line. The nature of a line can vary from the feathery touch of a pencil lead to the thick, solid stroke of a graphite stick or charcoal, and the particular quality of line can be infinitely modulated according to the character of the artist and the nature of the pose. Line can be expressive in a direct, vigorous way (*see* pp. 38-39), or carefully controlled and adjusted to echo closely the form of the model. In both the studies shown here, a single clear outline emerges from the softer, roughly drawn marks of the earlier and more tentative stages of drawing.

Measure distances with a pencil by sliding your thumb up and down it.

1 ▲ Half-close your eyes and try to take in the whole shape of the subject. Sketch this in very loosely and lightly using a graphite pencil, such as a 3B; these first marks will be a useful guide as you measure your way around the figure.

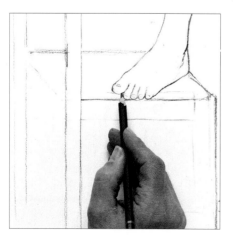

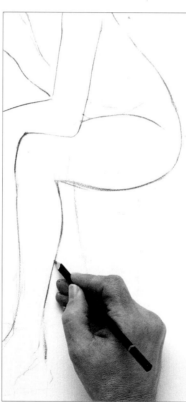

2 ◀ Look carefully at the difference in tone between background and figure. Where the figure is pale and the background dark, make the line a little heavier than where the contrast is less distinct. This aspect of touch is what gives a line drawing its particular resonance.

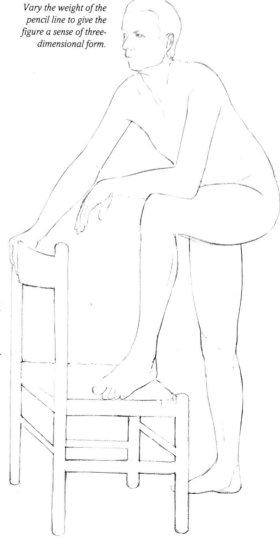

Vary the weight of the pencil line to give the figure a sense of three-dimensional form.

3 ◀ Work with firmer strokes around the contours of the figure, refining the pencil lines with an eraser. Finally, work on details such as fingers and toes. Try to ensure that the details retain a similar feel to the rest of the drawing.

Negative spaces
The background spaces enclosed by parts of the body or by the legs of a chair create shapes often referred to as "negative spaces". If you concentrate on these where appropriate, the figure should emerge with some accuracy from the background.

Standing figures

You need to be able to see the whole standing figure at a glance, so make sure you set up your easel far enough away (*see* pp. 30-31). If you are too close, it will be more difficult to set the whole figure comfortably within the rectangle of your paper.

1 ▶ Willow charcoal can be used with a light touch to sketch in the broad outlines of the figure. You can adjust the line as you work by rubbing gently with your fingertips or an eraser. Before committing to a line, rehearse it mentally. You can mark "arrival points" for short or long sections of line around the figure and use these as guides as you draw.

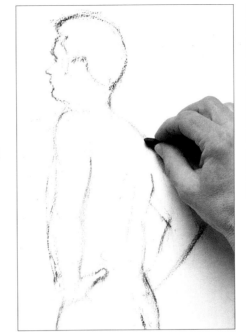

(see pp. 30-31)

Materials

Willow charcoal

3B pencil

Plastic eraser

2 ▶ Once the outline has been plotted, draw a series of strong, fluent charcoal lines to create a sense of the solid structure of the pose. These denser-toned strokes, made in a series of separate curved lines, will be read by the eye as a continuous outline.

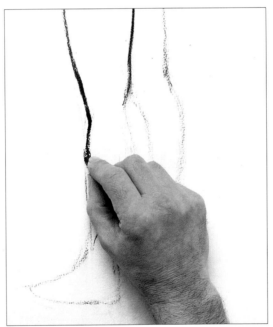

3 ◀ Adjust the quality and flow of the line with the sharp edge of a plastic eraser. This technique allows you to strengthen and refine a contour and give a sense of the tension in a muscle.

Study of standing figure

Although there are no areas of shading and no reference to background in this outline drawing, it still gives us a real sense of the standing figure planted solidly on the ground. The thigh and calf muscles push out their linear contours, as if filling the spaces between them with flesh and blood.

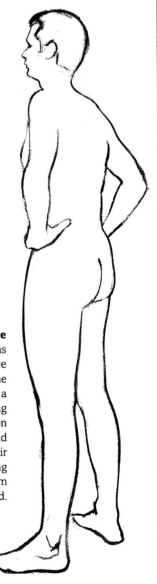

TONAL STUDIES

ALTHOUGH A SIMPLE LINE DRAWING can give some indication of the way light falls across a three-dimensional figure, it is the depiction of tone that allows us to read a figure in a fully dimensional way. The distinction between line and tone is somewhat arbitrary, since tone is often created through line and in many drawings there is a complete integration of the two. There are various ways of capturing tonal variations through smooth graduations from dark to light, and it is worth making a series of studies to experiment with shading techniques and materials. In the second study shown here, the substitution of a Conté pencil for the crayon means that more detail can be incorporated.

Lighting effects
Try different variations in lighting to experiment with tonal effects. Strong light will dramatically accentuate the lights and shades in clothing.

1 ◀ Lightly sketch the shape of the reclining figure using the flat side of a brown Conté crayon. The model's clothes are relatively tight-fitting and follow the form of the body closely. The grain of the paper will break up the line of the brown crayon to give half-tone effects.

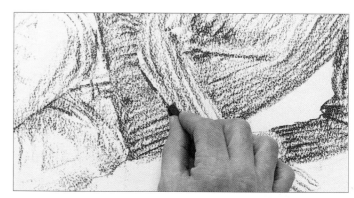

2 ▲ Press the edge of the crayon firmly below the line of the arm to give a deeper shadow in rich red-brown tones. This will bring the arm forward of the body. Work gently, trying to retain a soft, relaxed feel to the tones.

3 ▶ Shade in the shoes to a similar depth of tone to the shadows of the sweater; this will contribute to a sense of overall form. Avoid over-complicating this rough tonal study with details such as the shoelaces and eyelets, but finish working when you are happy that the broad variations in tone have been captured fairly accurately.

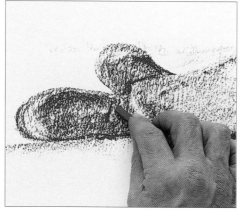

Reclining figure
The finished study has a loose, leisurely feel, with well-observed variations of tone modelled economically with the Conté crayon. At the risk of sacrificing the spontaneous mood, the drawing could be worked up further to integrate the figure into its setting.

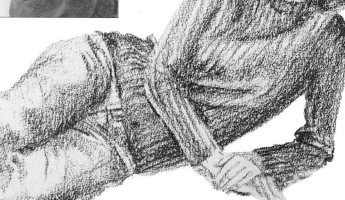

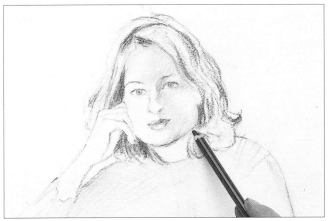

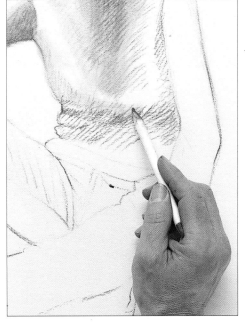

Materials

Brown Conté pencil

Paper stump

Brown Conté crayon

Plastic eraser

1 ▲ For a second tonal drawing, replace the crayon with a Conté pencil and begin by sketching in the outlines of the seated figure. Now work up the image in detail, starting with the face and hair; the finer line of the pencil allows sensitive detail to be incorporated. Gradually build up dark tone in the hair and the shadow under the chin by using a gentle hatching technique.

3 ▸ Move down the drawing, establishing the areas of light and shade on the clothing. Create a depth of tone in stages, shading one layer over another. Below the jeans the socks are in deep shadow, so use firm, controlled strokes of the Conté pencil. Observe the sitter constantly to assess the tonal variations in the figure as a whole.

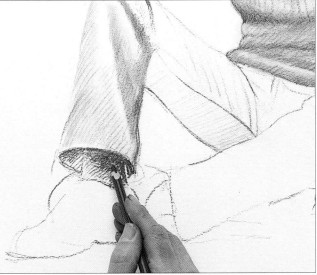

2 ▲ Carefully shade with diagonal strokes across the vertical lines of the sweater. This shading technique reflects the natural movement of the artist's right hand and will give the drawing a natural fluency, however detailed it becomes. Soften the shading with a paper stump, which produces subtle smudged effects.

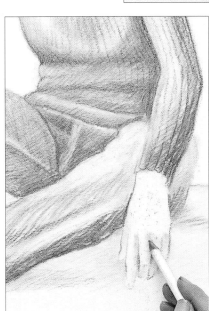

4 ◂ Leave the model's left hand quite pale to indicate the fall of bright light from ahead, and soften the marks of the pencil with the paper stump.

Tonal study
In the finished study, the tonal modelling gives a strong sense of the pose, with the angle of the model's right arm echoing that of her left leg and her left arm that of her right leg. This creates a circular movement that keeps the viewer's eye travelling around the drawing.

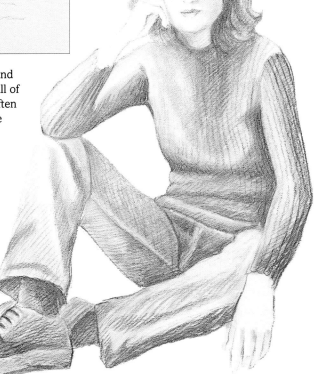

35

Gallery of Long Poses

THERE IS A PARTICULAR satisfaction in completing a highly worked drawing that is the result of hours of careful observation yet maintains the freshness of the drawing media. The images shown here retain a sense of immediacy while expressing something of the artist's sustained interest. They also represent a wide variety of styles, from the pattern-making approach to design in the Toulouse-Lautrec and the nervous touches of colour in the Jones, to the dramatic chiaroscuro of the Hardwicke and the gentler tones of the Moser.

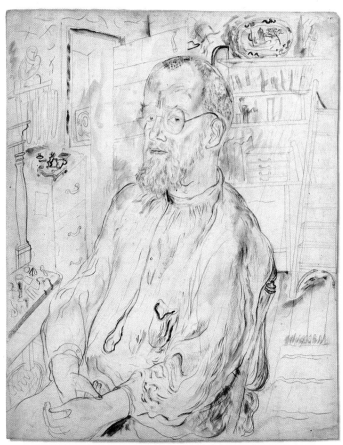

David Jones, *Eric Gill,* **1930,** *61 x 48.2 cm (24 x 19 in)*
The sitter, an artist of distinction himself, looks ahead quizzically as he is drawn and there is a sense of wariness, an edge that can often exist between artists. David Jones works carefully, almost myopically, over the whole area of the paper. Every touch of the pencil, every smudge of watercolour paint seems to hold its breath. Once in a while, an area seems to break out in a bold rash, as in the red below the sitter's left arm.

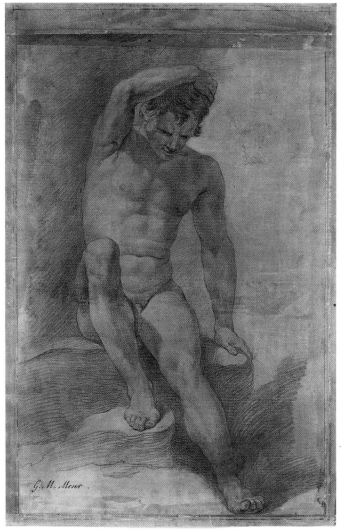

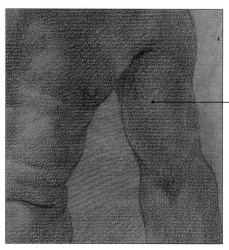

The meticulous tonal shading helps place the figure in three-dimensional space.

George Michael Moser RA,
***Male Academy,* date unknown,** *57 x 38 cm (22¹/₂ x 15 in)*
This chalk drawing demonstrates an academic approach to figure drawing, in which the model is represented in some detail and with considerable tonal shading. The drawing also reveals a common problem with very long poses: when the artist concentrates intensely on one area at a time, he may not bear in mind the effect of the whole. Here, the figure's right arm has been drawn on a different scale to the arm on the left.

Henri de Toulouse-Lautrec, *At the Nouveau Cirque, Clowness and Five Stuffed Shirts,* **c.1892,** *59.5 x 40.5 cm (23¹/₂ x 16 in)*
This study for a stained glass window has a liveliness and a presence that comes from genuine observation from life. The woman leans forward in her chair, her back erect, captivated by the performance of the dancer in the centre of the ring. The shape of the dancer, with her arching back, forms an ellipse in the composition with the spectator's left sleeve and arm.

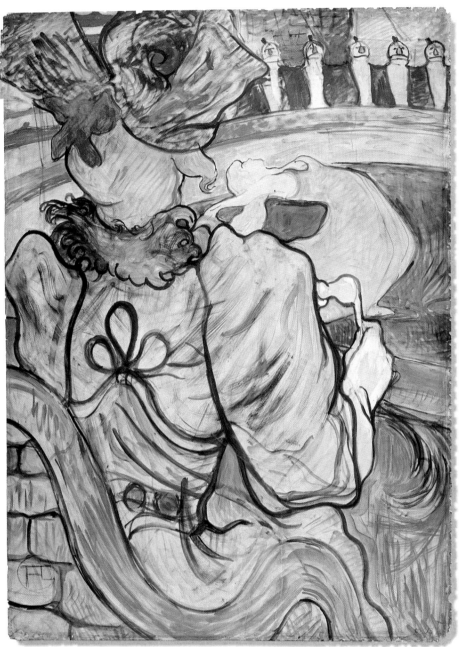

The purity of the colours in this detail sustains the freshness of the image. Loose, relaxed brushwork gives the study a sparkling immediacy.

Linda Hardwicke, *Top of the Tower,* *80 x 59 cm (31¹/₂ x 23¹/₄ in)*
The low viewpoint gives a sculptural quality to this carefully constructed image. The woman is set partly against a dark background to the left with her profile silhouetted against the window to the right. This transition makes for a tonally intriguing work, with the black background containing the image of the trunk and the white light giving a sharp focus to the face. The effect is a sense of separation, as if the woman is entirely in a world of her own.

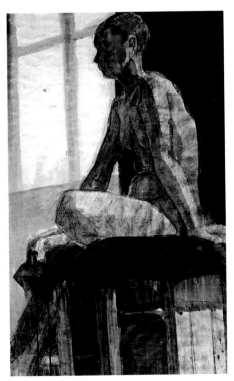

The drawing has been constructed in a series of interlocking tones, with washes of varyingly diluted ink glazing the soft charcoal.

37

DIRECT LINE DRAWING

ONCE YOU HAVE PRACTISED drawing the figure using a measured linear or tonal approach, it can be refreshing to try a very bold technique. The idea is to look and draw five, ten or fifteen-minute poses without any preliminary rough sketching and without modifying the lines at all. In order to draw the figure so directly, you will need to focus intensely on your subject and on each mark you make. If you use a pen or a brush rather than a pencil or charcoal, you will not be tempted to erase a line and start again. The smooth clarity of line produced by a Rollerball or fibre-tipped pen is particularly appropriate for this kind of rapid, spontaneous work. Direct line drawing is testing and you have to accept some inaccuracies as unavoidable. But it can also produce images of great immediacy and fluency that reflect the concentration involved in their making.

Self-portrait
A self-portrait is a good way to try rapid line drawing for the first time. The bold lines of the clutch pencil have recorded in a few strokes this candid reflection.

Finding a point of focus
Every pose has a unique and unexpected appearance, so spend a minute or two looking carefully at the figure before committing pen to paper. Begin drawing at a point of focus, such as the face, and work outwards from there, trying to relate every line to the one you made before it.

Fluent strokes
Rehearse each line mentally before you draw it. Here, the blue Rollerball pen charts the contours of the figure in a series of short but fluent strokes.

Clear lines
The simple clarity of the technical pen line produces a sympathetic and uncomplicated picture of the sleeping model, neatly curled up in a self-protective pose.

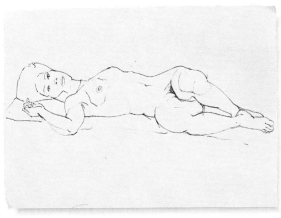

The lines of the ball-point pen are quite tentative in this first study.

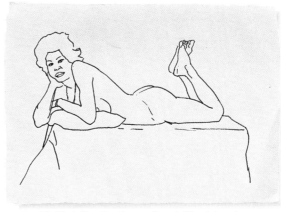

The black fibre-tipped pen makes a bolder statement.

Materials

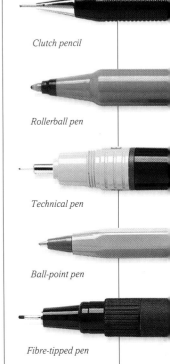

Clutch pencil

Rollerball pen

Technical pen

Ball-point pen

Fibre-tipped pen

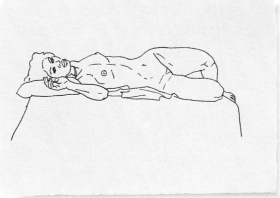

Details of setting are kept to a minimum.

A full sense of the form is given in a few fluent lines.

Series of studies

It is useful to make many studies of similar poses, varying the drawing tool occasionally. The first study in blue ball-point pen (*top left*) is noticeably more tentative than those made in black fibre-tipped pen, where the artist has established a clearer mental image of the form of the model before starting to draw.

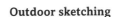

Standing and sitting poses

Whether the figure is standing, sitting or reclining, imagine how the pose will fit on to the paper. The standing figure (*left*) has emerged in good proportion, though the left foot just trails off the edge of the page. If, as you draw, you realise that the whole figure will not fit, you can still give a full sense of pose and clothing in the space you have.

Outdoor sketching

Studio work will prove enormously helpful when you come to make visual notes of figures you see around you outdoors. Sunbathers on a beach provide ideal subjects for direct line drawing, and might later be worked up in a painting in the studio.

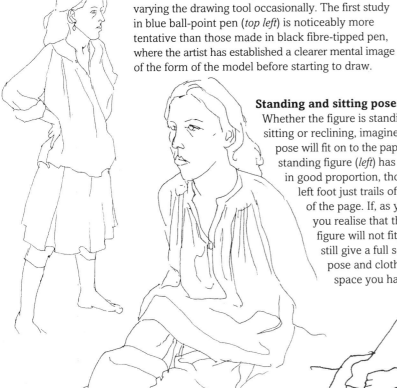

Very few lines are required to suggest the style of clothing.

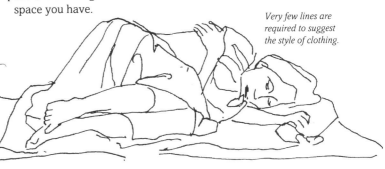

THE MOVING FIGURE

DRAWING A MOVING FIGURE convincingly presents the artist with a considerable challenge. The model may repeat the movements of a particular action while you attempt to represent it or may try to hold a movement long enough for you to capture it. Sometimes, artists use devices such as taping charcoal to long sticks so that there is an inherent mobility in the drawing style that reads as movement in the finished study. This works very well for rapid sketching, but not for a more highly worked study. For this, photographic reference is essential.

Movement can be expressed through the rapidity or intensity of the marks made on the paper.

As the figure moves forward, there is a continuous re-adjustment of balance.

Impending motion
A set of photographs will show clearly what happens during a given movement. You can use them to help identify the precise moment at which the position of the body seems to sum up the motion in the way that you would like to express it in your drawing. In the third image from the left, the walking figure has a sense of purpose that shows an impending movement (*left*).

Running figure
Work from life with a sequence of static poses and run them together in your mind to create an impression of the athlete thrusting out of the starting blocks. Look for the single pose that might provide the basis for a drawing. Here, the fourth pose in the sequence gives a good sense of forward motion.

Photographs

The development of photography, film and video has done much to provide artists with clear imagery of the moving figure that would have been impossible to imagine in the past. We can now study images of swimmers, divers, gymnasts, dancers and even free-fall parachutists, all of which allow us to observe and draw from the figure in new ways. Such imagery extends the scope of figure drawing and suggests new themes and ideas for art. No model would be able to hold this pose in a studio situation (*right*), but the clarity of the photograph shows sufficient detail for an artist to use it as reference for a credible figure drawing.

A good understanding of the way the torso twists and bends is required for drawing the moving figure.

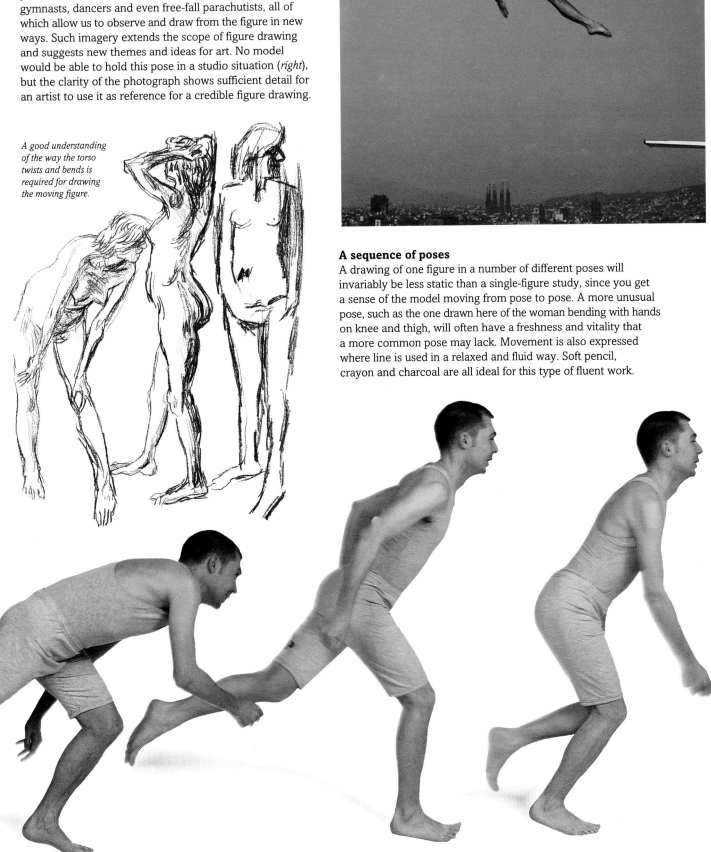

A sequence of poses

A drawing of one figure in a number of different poses will invariably be less static than a single-figure study, since you get a sense of the model moving from pose to pose. A more unusual pose, such as the one drawn here of the woman bending with hands on knee and thigh, will often have a freshness and vitality that a more common pose may lack. Movement is also expressed where line is used in a relaxed and fluid way. Soft pencil, crayon and charcoal are all ideal for this type of fluent work.

CAPTURING MOVEMENT

FIGURE DRAWING FROM LIFE that expresses motion will invariably display a considerable amount of rapid movement in the medium and technique used. When you are faced with a pose that is held only briefly or by a model who is literally moving, it feels most appropriate for the pencil or charcoal to move swiftly across the paper in many directions as you attempt to come to terms with what you see. Such vigorous work can be very hit-or-miss but it can also be quite exhilarating.

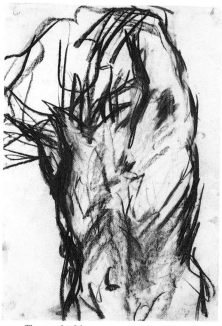

The stretch of the torso is accurately expressed.

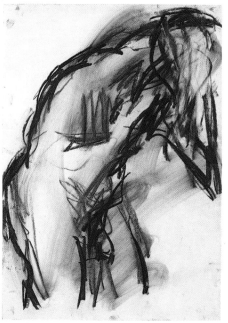

Energy is concentrated in the arms and neck.

Fluent lines

One of the best materials for capturing movement is charcoal. Use thick sticks to weave fluent lines around the trunk, arms, head and thighs of the figure. If seen in isolation, some of these lines would seem to be abstract scribbles, but they come together to create a powerful impression of the man stretching across the central diagonal of the picture plane. The small scale of the head gives an indication of the massive bulk of the figure as he adjusts his balance during movement.

Figure undressing

The figure undressing involves a pose or series of poses that a model can easily hold and repeat. In the first of these charcoal drawings (*above left*), the figure's easy stretch is captured with a sense of solidity and mass, while the fabric of the clothing is drawn with less shading to express its lightness. In the second drawing (*above*), there is more tension and anxiety as the man leans forward to get the clothing over his head.

Focus of energy

Explore poses in which the energy of a movement can be concentrated in one area of your composition. In the study of a figure with hands clasped together behind his back, the energy is held in the centre of the composition, with the figure's neck cut off at the top edge of the paper. In the second pose, all the focus of the drawing is in the lower half, as the figure scrabbles with his hands at the bottom edge of the composition.

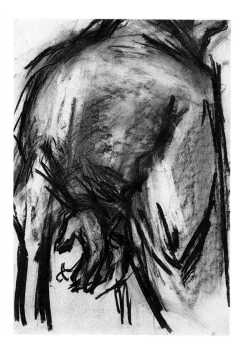

The focal point of the study is the firmly clasped hands.

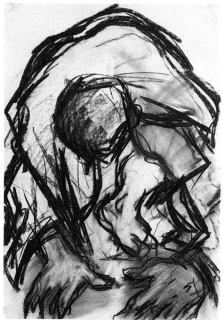

Tension is focused in the lower half of the composition.

Leaping figure
Even a rapidly made drawing of a figure leaping through the air proceeds by means of a series of identifiable stages.

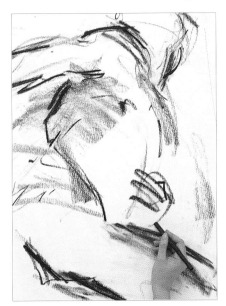

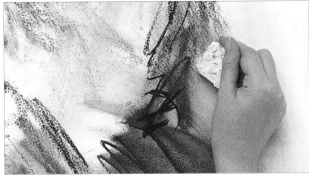

2 ◀ Draw over the trunk and arms, partially erasing some of the earlier defining lines by rubbing with the fingers. This will give the impression of the arm moving up and down and the figure rocking slightly. Pick out highlights with a putty eraser to suggest the smoothness of the bare skin.

1 ◀ Capture the essence of the movement in the first few lines of your study. Use the broad side of the compressed charcoal for the soft sweeping strokes of tone and use the end of the stick for the clearer, cleaner lines.

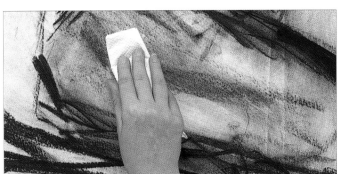

3 ▲ Using a piece of kitchen towel or tissue, gently blend the charcoal on the thigh to give an indication of the shadow of the muscle. The raised grain of the paper will pick up the charcoal and give a textured, half-tone effect.

Leaping figure
In the finished study there is a balanced unity of vigorous shading and bold, deep defining lines. But there are also smooth indications of skin texture in highlighted touches picked out with an eraser. The whole drawing has an active, worked-on feel that recreates the tension and energy of the figure in motion.

Materials

Compressed charcoal

Putty eraser

Blending and smudging techniques create a blurred effect in the drawing that suggests the speed of movement.

The edge lines of the thigh are repeated several times to suggest upward and forward motion.

Ghislaine Howard

Kitchen towel

GALLERY OF RAPID POSES

THOSE WHO ARE NEW to drawing or painting sometimes feel that the more work you put into a study, the better it is. But when we are drawing, we need to be aware that we are expressing feeling and not merely engaging in some kind of mechanical process. Making rapid or short pose studies can free artists from the tightness of style that sometimes arises when too many careful studies have been made. The drawings featured here, all made relatively quickly, demonstrate the power and underlying complexity of an economical approach. They show the results of applying a particularly intensive focus to the activity of drawing itself. From the youthful student study to the assurance of the mature artist's drawing, they each have a sense of fluency and movement, of a subject freshly observed.

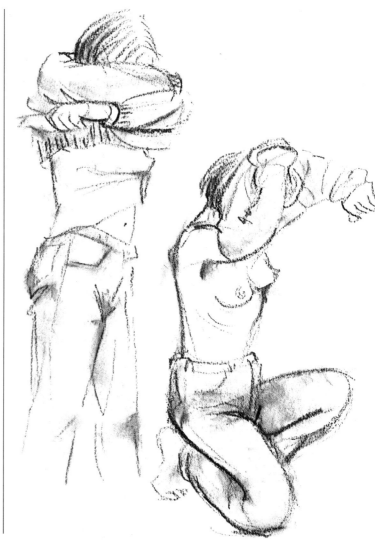

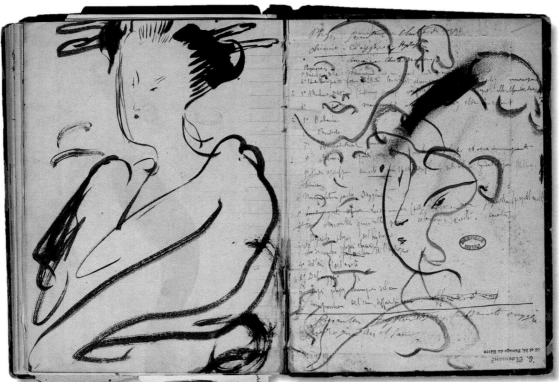

Angela Waghorn,
Two Studies in Blue,
42 x 30 cm (16¹/₂ x 12 in)
These rapid studies were made by a student using water-soluble coloured pencil. They have a lack of pretension that makes them immediately accessible to the viewer.

Edouard Vuillard,
Japanese Woman,
1894, *approx. 14 x 60 cm (5¹/₂ x 23¹/₂ in)*
The economy of brush drawing on absorbent paper is nowhere more expressive and fluent than in the work of Oriental artists and calligraphers. Vuillard has paid homage to this long tradition in these eloquent drawings.

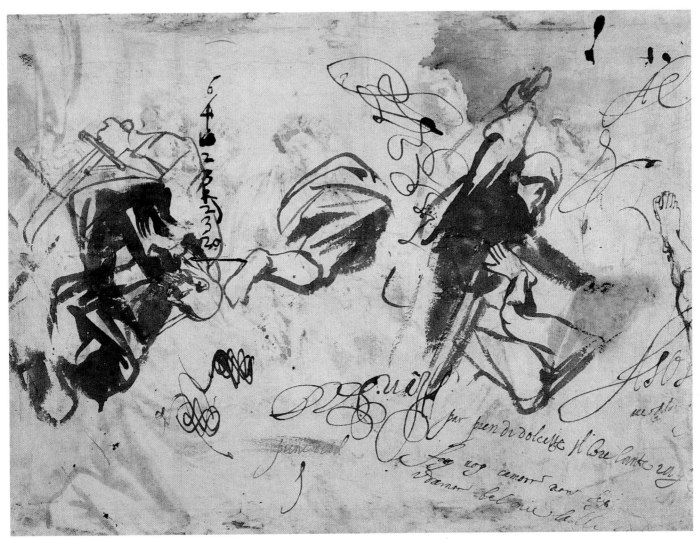

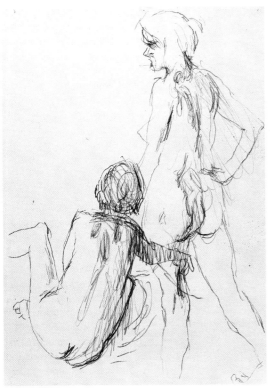

Anthony van Dyck,
Man Brandishing a Sword,
c.1620, _20.7 x 27.7 cm (8¹/₄ x 11 in)_
On the reverse side of a more finished drawing, you can sometimes find lively, uninhibited studies that celebrate the artist's gifts of expression and technical expertise. Here, Van Dyck uses the toe of the brush to create a series of fine and fluid defining lines, in which the grip of a hand on a sword, the curve of a calf muscle and the fierce intensity of a profile are powerfully expressed. The brush is then fully charged with ink in order to lay in bold tonal areas that express the dramatic nature of the poses.

Hans Schwarz,
Two Five-minute Drawings, _59.5 x 42 cm (23¹/₂ x 16¹/₂ in)_
In these two five-minute studies, the lines seem to have a restless life of their own as they edge their way around the forms. They are constantly on the move, defining and re-defining the figures, scribbling tone here or establishing a tenuous outline there. But the figures emerge with strength and humanity from the artist's investigations with the black pencil.

In this detail, the victim's foot pushes against the dark bulk of the figure behind and the thigh muscles bulge with the effort.

MOOD & ATMOSPHERE

THE MORE DRAWING YOU DO, the more you will become aware that a successful work goes beyond the merely accurate rendition of a subject and begins to express other less definable elements, such as mood, spirit and truth. For those who see the work, these are the elements that give it real meaning. Before you embark on a drawing, ask yourself what kind of mood or atmosphere seems to be generated by what you see in front of you and whether there may be subtle ways in which you can emphasize it. Perhaps you can adjust the setting, heighten or neutralize the colours, or modify the pose in such a way as to give your work a particular resonance. Your choice of materials will also have a significant effect on the mood of your drawing.

A domestic interior can provide the setting for a series of works. Different moods will be created according to the materials, style and format you choose (see pp. 48-49).

Background elements

The vase and flowers are very specific elements within the setting and it is interesting to see how differently the artist uses them in the separate versions of the scene. In the pastel work (*far right*), the soft lilac pinks of the pot become important, whereas in the brush drawing (*below*), it is the hard-edged blue vertical vase and bright yellow flowers that form the focus.

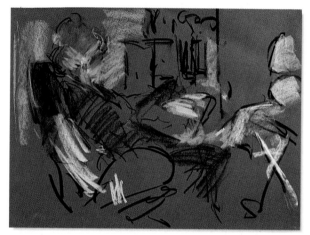

Toned paper

Choose the tone of your paper carefully. Blues and greys provide cool, muted backgrounds on which warm shades are accentuated, such as the lively touches of orange and yellow (*above*).

Brush drawing

To capture your instinctive response to a subject and setting, make a direct and spontaneous brush drawing using bold, vigorous strokes of the brush. This technique often creates a strong and vital image in which all the components are swiftly and clearly defined. Here, the artist captures the alertness of the sitter and transforms a fairly ordinary interior into a vibrant one.

Composition

Your decisions about composition will have a direct effect on the mood of your drawing. In this pastel study, the artist opts for a portrait format, focusing on the sitter and excluding much of the background. The stillness and concentration of the sitter are emphasized and a scene of cosy solitude created.

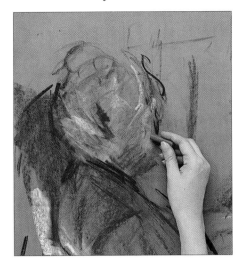

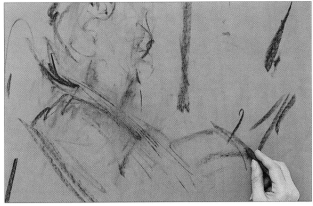

1 ◄ Lightly sketch in the main forms of the composition on toned paper. A neutral brown-grey will provide good half-tones. Press gently with the charcoal for large areas of tone; a heavier pressure will make the tones too deep for the subsequent colours to retain their brightness. Use your fingers to rub off any excess charcoals.

2 ◄ Apply warm brown and yellow pastel colour to the hair and face; this will bring it forward into three-dimensional space. At this stage, these colours may seem over-saturated, but as colours are layered over one another, the effects will become more subtle.

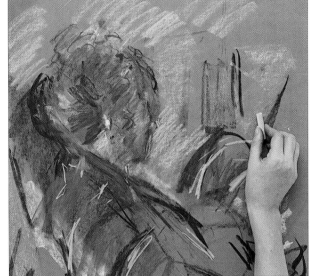

3 ▲ Loosely shade white into the area around the face and sketch in the chosen elements of the backdrop, such as the cabinet door and the vase. These objects will frame the figure and give a homely, intimate mood to the drawing.

Portrait study on toned paper

The woman sits comfortably within the composition, her red hair providing an area of bright focus. The blues and greens of her tartan robe are used as a base for the lively flecks of white, while the touch of bright red on the cushion and strokes of pink on the vase give the drawing warmth.

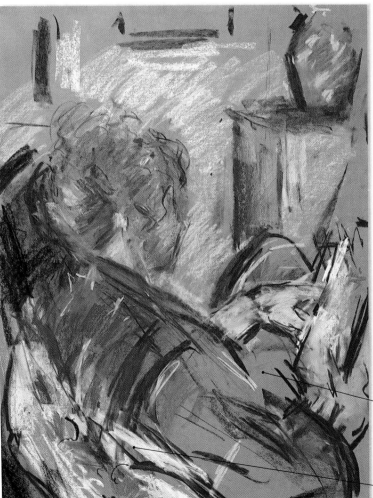

The brown-grey paper provides a muted, half-tone background for the vivid touches of pastel colour.

The soft, dancing strokes of the pastel bring the surface to life and create a warm and gentle mood.

Ghislaine Howard

Materials

Compressed charcoal

Selection of pastels

1 ▲ Modify the original composition (*see* pp. 46-47) in order to accommodate the full-length figure and the chosen background elements in a horizontal format. Sketch the shapes loosely and boldly with compressed charcoal; this will enable you to adjust the line and tone freely as the drawing progresses.

COLOUR & ENERGY

WHEN YOU ARE MAKING a fully resolved drawing in a single sitting, you may find yourself working at a pitch of energy and concentration that sustains you through the whole process. This high level of excitement can carry the mood of the drawing along with it, so that you are barely conscious of having to make cool decisions about the atmosphere of the drawing – it simply arises out of the activity itself. This full-length study, made in charcoal, pastel and Conté crayon, is very well planned in terms of composition and colour harmony, yet it still buzzes with the energy of the single sitting. The viewer is left with the same sense of engagement with the image that the artist herself clearly felt.

2 ▶ Once the composition is established, begin working in colour with pastel. Pastel can easily be blended or overlaid with another colour, so you can work instinctively and rapidly, without worrying about accuracy.

3 ▶ Continue working your way around the composition. Build up colour, using the mid-blue tone of the paper and the rich black of the compressed charcoal as the basis for your tonal work. Layer oranges and reds for the hair, applying the pastel thickly. Use your fingertips to blend the colour and describe the soft texture of the hair.

4 ▲ Now introduce Conté crayon into the drawing for the flat shapes of the background. Use the edge of the crayon to build up colour and tone. Here, the area around the lamp is bright in tone and the yellow provides a mid-to-light transitional tone between the blue paper and the white area illuminated by the lamp.

5 ◀ Use vivid blue for the figure's robe. Tonally, there is a similarity between the blue of the pastel and that of the paper, but the pastel is a richer hue and has a creamy texture that works well with the black charcoal at the centre of the composition.

6 ◄ Draw sharp flecks of orange-red pastel on the blue of the robe. These are complementary colours and so mutually enhance each other. You need apply very few touches of red in relation to the blue to achieve this particular colour harmony.

Materials

Compressed charcoal

Selection of Conté crayons

Soft pastel stick

7 ▶ Add touches of yellow to the white and orange-red colours around the lamp. These three are adjacent colours and will create further colour harmony within the drawing. Apply the pastel vigorously in the larger areas of shading and with a little more precision around the rim of the lamp shade.

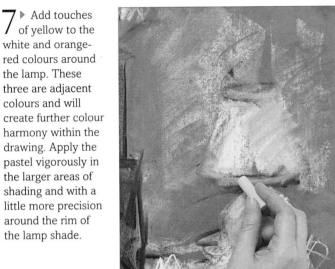

8 ◄ Make any finishing touches, such as the addition of yellow highlights to the hair. This will create a vivid tonal contrast with the deep charcoal blacks in the back of the chair.

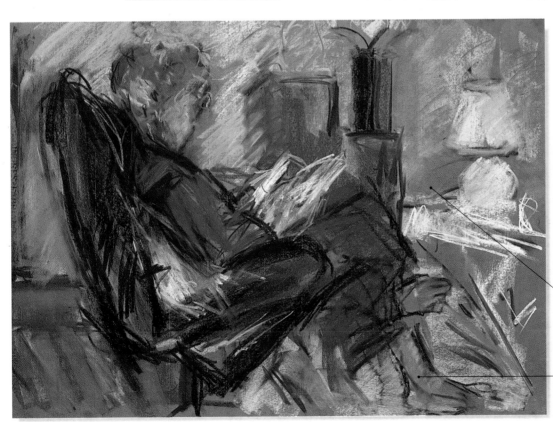

Study in mixed media
The finished study has a genuine sense of the artist entering into the spirit of the situation. The pose may be a reflective one, but there is a sense of mobility about the figure. This alertness arises from a free and open technique, clever exploitation of the textures of the different media and a bold use of colour.

The layer of Conté colour interacts in a lively way with the dark-toned paper.

Rich pastel hues are added to the Conté and charcoal, creating a multi-layered colour effect.

Ghislaine Howard

GALLERY OF MOOD

THERE ARE MANY ELEMENTS in the complex web of factors that make up our reading of the mood or atmosphere of an image. These include the actual setting, the time of day, the nature of the lighting, the clothing and actions of the figure and the angle from which the subject is viewed. The choice of medium is also of great importance, as can be seen from the range of images featured here. Some artists might argue that the mood of a work is something indefinable that is generated through the process of drawing, while others may feel it necessary to establish beforehand exactly what the atmosphere should be.

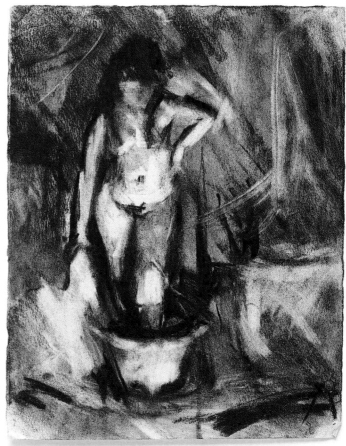

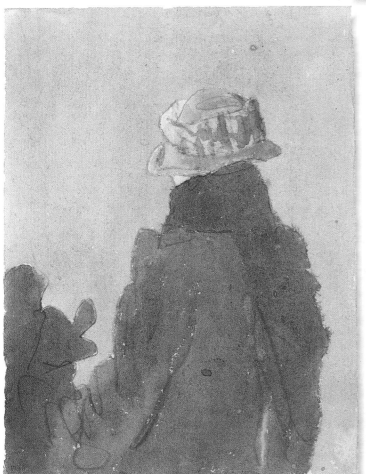

Neale Worley, *Woman in a Tub,* 20 x 15 cm (8 x 6 in)
The influence of Rembrandt can be seen in the dark-toned chiaroscuro of this study, with its dramatic lighting picking out the figure of the woman in the bath. The hard edges and high contrast of the highlighted tones suggest a powerful, direct light source that gives the work something of the atmosphere of a stage set.

Gwen John,
Young Woman in a Hat, c.1910, *16.4 x 12.8 cm (6¹/₂ x 5in)*
At first sight, this is a simple, economical study of a woman in hat and scarf seen from behind. We catch only a glimpse of her face, a tiny exposed triangle, which gives a psychological dimension to our reading of the high scarf, the hat pulled down and the all-covering coat, as if the woman feels the need to protect herself. She seems to parallel visually the artist's own self-effacement as she makes her unobtrusive visual notes.

In this detail, the pencil lines have been drawn lightly on toned paper before the application of watercolour in blue-grey for the scarf and a warmer low-key red for the hat.

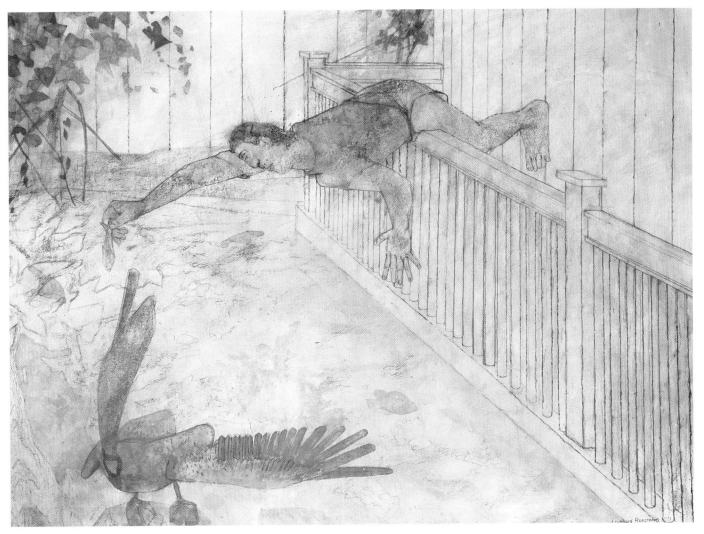

Leonard Rosoman RA,
***Study of a Man Feeding a Blind Pelican*, 1991,** *81.5 x 109 cm (32 x 43 in)*
Although we may often consider mood in darkly dramatic or psychological terms, there is an equally important lighter aspect. Here, the very directness of the design, the large, diagrammatic hands and feet of the figure and the bold symmetry of the shape of the pelican with that of the man all help set an engaging and amusing tone. The orange-yellow glow sustains the sunny warmth of the image.

Georges Seurat, ***Crouching Boy, c.*1907,** *32 x 25 cm (12¹/₂ x 9³/₄ in)*
Seurat's tonal Conté crayon technique gives his figure a timeless, sculptural quality. There is no detail, so our interpretation of the work has to come from a reading of the broad shapes, the angles of the limbs or head and, crucially, the way the light falls across the figure. The subject seems both self-absorbed and vulnerable, partially protected by the darkness of the shape – possibly a tree – behind him and partly exposed to the light behind.

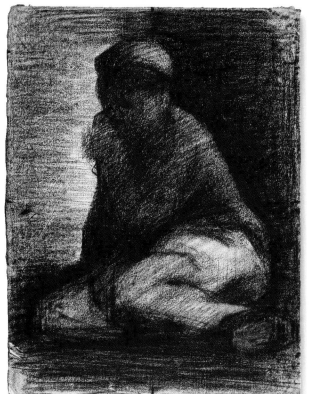

Seurat employs a complete range of tones from dark to light in this detail. The grain of the paper is used to create half-tone effects.

YOUTH & AGE

ARTISTS WHO ARE CONCERNED to give expression to the reality of the world around them reject idealized notions of beauty or cultural stereotypes in favour of a more objective vision of what exists. In figure drawing, you can often find yourself focusing exclusively on models of a particular age and type. But to get an idea of the great diversity of people of all ages, simply take a good look at everyone you see as you walk along a busy street or through a shopping mall. Make an effort to draw people of all ages. Focus on the physical changes that age brings about and try to express elements of a sitter's character through pose, clothing and setting.

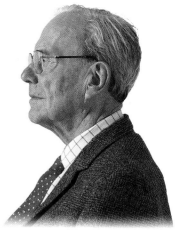

Older people
The physical signs of ageing may be evident, but older people often demonstrate great dignity in their bearing and manner.

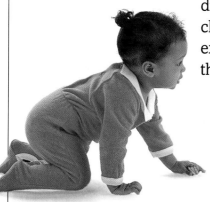

Photographic reference
Very young children are rarely still when they are awake and it can be impossible to do more than make the most rapid thumbnail sketches. Photographs can be a helpful reference for more finished drawings.

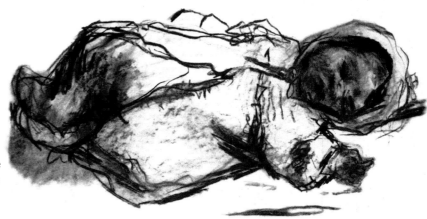

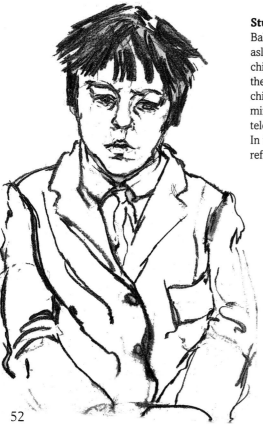

Studies of children
Babies make wonderful subjects for drawings, especially when they are asleep. Charcoal is an excellent choice of medium for sketching young children because it can be used to create an appropriate softness and the lines are easily modified for adjustments to shape or features. Once children are at an age when you can ask them to sit for you for a few minutes, make sure they are comfortable and possibly absorbed in a television programme, video or book while you make your drawing. In this charcoal sketch (*left*), the boy's bemused expression gives a refreshingly unsentimental quality to the drawing.

Posture
Between the stumbling first steps of the toddler and the shuffling steps of a man in his eighties, there lies a lifetime of movement and posture. Although an older ballet dancer might continue to move with the body straight and head held high, there is generally a rounding of the shoulders, a stooping of the back and a stiffening of the joints as people get older.

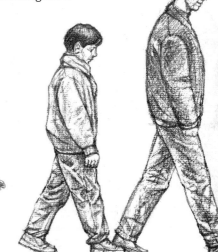

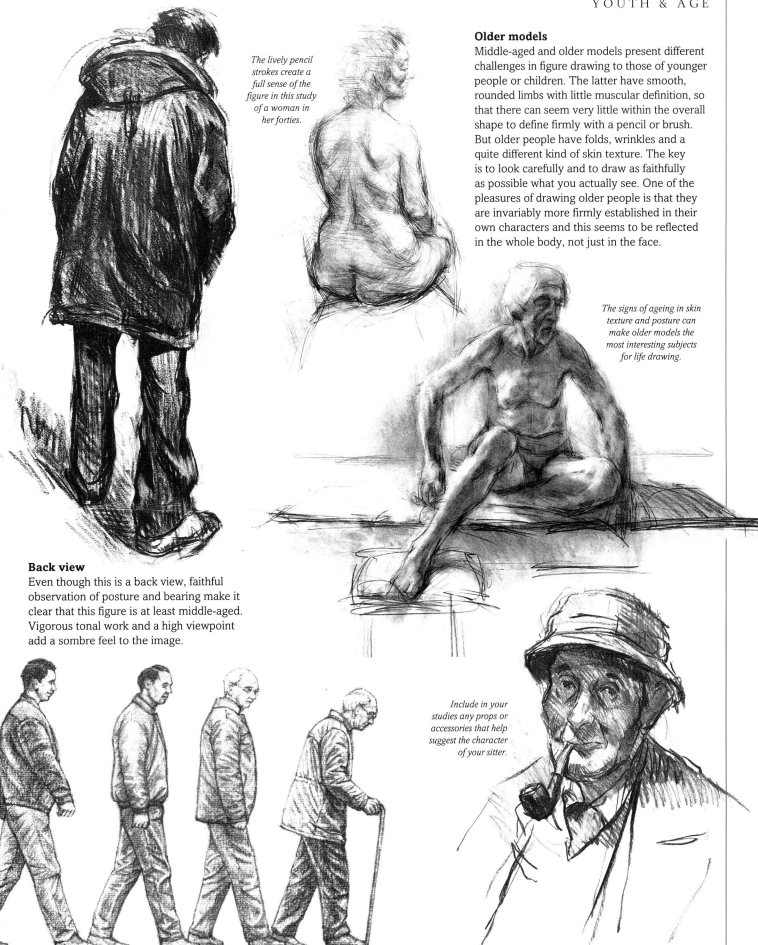

The lively pencil strokes create a full sense of the figure in this study of a woman in her forties.

Older models

Middle-aged and older models present different challenges in figure drawing to those of younger people or children. The latter have smooth, rounded limbs with little muscular definition, so that there can seem very little within the overall shape to define firmly with a pencil or brush. But older people have folds, wrinkles and a quite different kind of skin texture. The key is to look carefully and to draw as faithfully as possible what you actually see. One of the pleasures of drawing older people is that they are invariably more firmly established in their own characters and this seems to be reflected in the whole body, not just in the face.

The signs of ageing in skin texture and posture can make older models the most interesting subjects for life drawing.

Back view

Even though this is a back view, faithful observation of posture and bearing make it clear that this figure is at least middle-aged. Vigorous tonal work and a high viewpoint add a sombre feel to the image.

Include in your studies any props or accessories that help suggest the character of your sitter.

53

PORTRAITS

THE PORTRAIT IS AN ESSENTIAL ASPECT of figure drawing because it allows you to concentrate intensely on the face and features of your model. This is especially helpful to your drawing technique if you have been making a series of full-length studies that give no more than a vague indication of the shape of the head. The great challenge of a portrait drawing is to express accurately both the appearance and character of the sitter. Certainly, the best portraits do seem to have that kernel of resemblance that strikes a chord of recognition with the viewer. But however practised you are, there will be times when a portrait works and times when it does not.

The sitter has a strong face, with clear, well-defined features. These are accentuated by the bright light from the left.

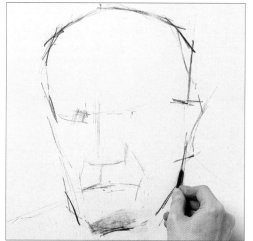

1 ▲ Lightly sketch a near-vertical line as a guide for the nose and a series of horizontal lines for the eyes and lips. Give yourself a fairly accurate idea of the scale of these features before marking the shape of the head.

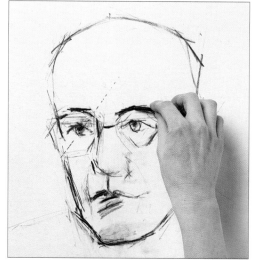

2 ◄ It is helpful to have some indication of the eyes and eyebrows early on in the work; they provide a central point of focus around which the portrait can develop. Use a thin stick of charcoal for the eyelids and irises and a thicker stick for the lines of the eyebrows.

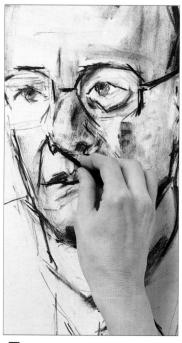

3 ▲ Now that the shape of the face and the essential elements of the features are clearly defined, add some light shading. Use the side of the stick for this and rub the charcoal into the paper with your fingertips. This will give some indication of the light source and will also relieve the whiteness of the paper.

4 ▶ Rubbing charcoal with your fingers will remove the depth of tone, so continue shading in those areas where darker tones are needed. Do not worry if your drawing looks a little uneven at this stage; any tonal inconsistencies can be resolved as you go on.

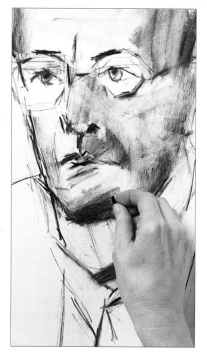

5 ▲ Once the basic tonal contrasts have been established, begin to work up the features in a little more detail. Delineate the upper lip and nostrils with strong strokes of the charcoal. Add definition to the glasses; the shapes of the lenses mirror the angular character of the face.

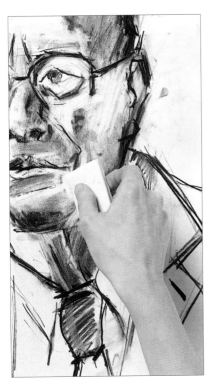

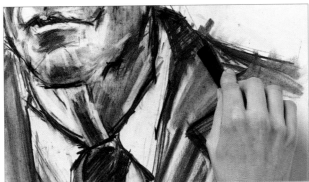

7 ◀ Give strong definition and tone to the jacket by working with the thickest stick of willow charcoal. The broad, stiff lines of the jacket create a firm structure for the pose. Although the large shapes and straight lines of the clothing give you the chance to work with long, rhythmic strokes, try also to retain an overall feel to the drawing so that no one part looks overworked.

6 ◀ Deepen the tones overall by using the same techniques of shading and blending as before. It is easy to smudge the drawing as you work, so keep an eraser at hand to remove any unwanted marks as you go. Pick out highlights with a putty eraser, moulding it into a point for the very precise marks.

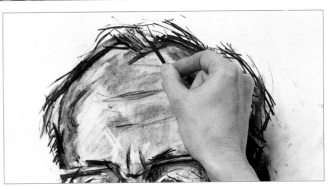

8 ▲ Look for any sense of imbalance in the portrait. If one area is too pale, strengthen its dimensionality with further shading. Add any final details, such as the strands of hair, using the thinnest stick of charcoal.

Portrait of George Baxter
The rich black tones of the completed portrait give it a good sense of energy and boldness. But there is subtlety, too, in the clean, dark touches of charcoal around the features. Both elements contribute to the immediacy and sensitivity of the portrait's message and the humanity of the sitter comes convincingly through to us.

Accurate observation of the scale and position of each feature helps achieve a good likeness.

Long, vigorous strokes around the shoulders give the portrait a strong framework.

The range of drawing techniques, from energetic hatching to gentle blending, demonstrates the great versatility of charcoal.

Materials

Selection of willow charcoal

Putty eraser

Rachel Clark

GALLERY OF YOUTH & AGE

IN THE DRAWINGS shown here, the journey from youth to age leads from the alert young girl curled up on a cushion and the boy walking with the vigour of youth, through the middle-aged characters on the New York subway and the seventy-year-old Australian, to the gentle image of Grandma sitting patiently on her big chair. Each work conveys a special quality about the person being drawn. That quality is a function of their age and situation, but essentially it arises because the artists have let the characters speak for themselves. There is a sense of respect for each subject and a lack of intrusion from the artists.

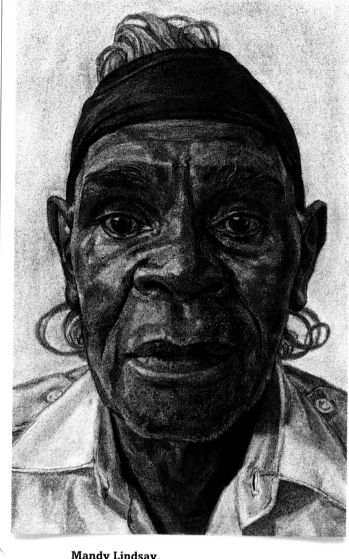

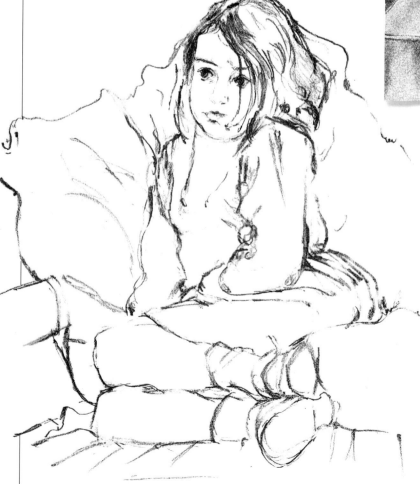

Mandy Lindsay,
Man from Mount Isa, *25 x 15 cm (10 x 6 in)*
In the eyes of this Australian Aboriginal we feel a separateness, a sad, dreaming quality. But at the same time, there is a genuine sense of the present moment. The artist has made a finely worked charcoal and Conté crayon drawing, in which the ridges and furrows of the face, so close to the viewer and so large in scale, become a metaphor for the landscape. Indeed, the carbonized wood of the charcoal, rubbed into the surface fibres of the paper, reminds us that the material itself is of the earth. The darkly shadowed face has the urgency of the present, but it is rooted in an almost ageless past.

Sue Sareen, ***Hannah,*** *40.5 x 30 cm (16 x 12 in)*
In this study, a quite different use of charcoal demonstrates an economy of line and a bright interaction with the white of the paper. The material has a real vitality that relates to the alert but relaxed figure of the young girl. The legs are tucked together and the forearm, with a hand in the lap, follows the line of the thigh. The trunk and head are slightly turned, but the girl's eyes engage directly with the viewer. The result is a vivacious dialogue with the viewer, in which the little girl seems to be the one in charge.

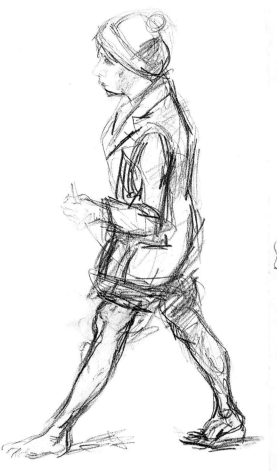

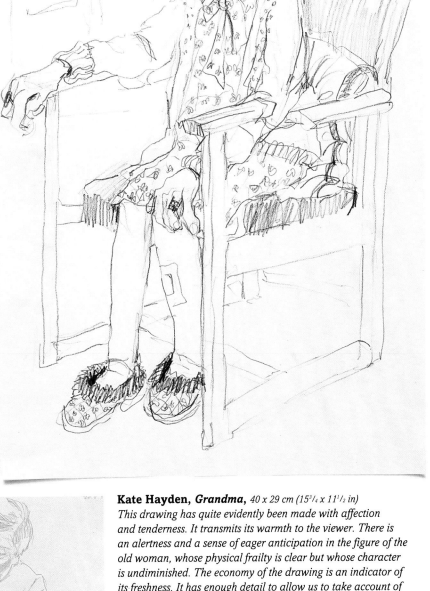

Max Beckmann, *Walking Youth,*
***c.*1910,** *30.7 x 22 cm (12 x 8³/₄in)*
There is nothing sentimental about this drawing of a walking youth. It is a vigorous, well-observed study, in which the figure emerges clearly from a range of pencil marks. At the back of the hat, coat and upper left leg, loosely scribbled tonal work gives a sense of dimension and movement, while around the lower legs, there is more linear mark making. This is rehearsed, repeated and adjusted, in order to give the correct proportions and create a sense of purpose.

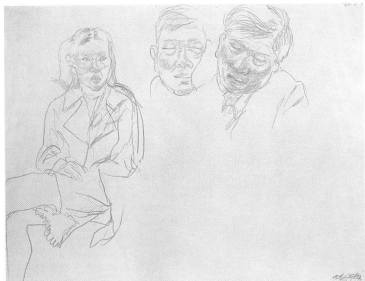

Kate Hayden, *Grandma,* *40 x 29 cm (15³/₄ x 11¹/₂ in)*
This drawing has quite evidently been made with affection and tenderness. It transmits its warmth to the viewer. There is an alertness and a sense of eager anticipation in the figure of the old woman, whose physical frailty is clear but whose character is undiminished. The economy of the drawing is an indicator of its freshness. It has enough detail to allow us to take account of the setting, but it is not so worked that it becomes heavy. It is an optimistic, celebratory work.

Avigdor Arikha, *New York Subway Drawing: Studies of Chinese Girl and Sleeping Man,* *23 x 30.5 cm (9 x 12 in)*
Busy public spaces are good places to make small, unobtrusive studies of the people who surround us. Avigdor Arikha's paintings and drawings have a presence and authority that stem from an intensely concentrated and objective approach to his subjects, combined with technical economy. The same concentration is evident in these small silverpoint studies, which seem to take us right back to where they were made.

GROUP COMPOSITIONS

THE PSYCHOLOGY OF A DRAWING that incorporates two or more figures is especially interesting, since by its nature a human relationship or series of relationships is being set up on the paper. Try to make clear decisions about what it is you wish to convey. Are you using two or three figures to tell a particular story or create a certain mood, or do you simply have a number of people to draw, such as a family gathering or a group of friends? The family is a good starting point for experimenting with group compositions. In the small-scale preliminary studies shown here, ideas about composition are explored in pencil and charcoal, with colour notes made in watercolour and gouache washes. The chosen composition is then fully worked up on a larger scale (*see* pp. 60-61).

Water-soluble crayons are ideal for rapid portrait studies.

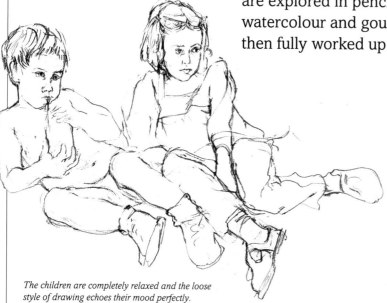

The children are completely relaxed and the loose style of drawing echoes their mood perfectly.

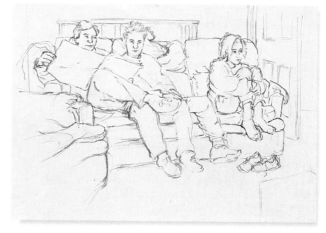

Composition

In your first sketch, keep the composition as simple as possible. Here, the horizontal band of figures across the paper is accentuated by the shape of the sofa. A television screen out of the frame and an open newspaper keep the subjects still and absorbed while being drawn. Even in this quick preparatory study, a few lively details are noted by the artist: it is the figure with the newspaper who watches television, while his companion glances over the newspaper at the artist.

Colour notes

Experiment with mood and tone by making rapid colour studies. Here, the watercolour wash fills the page, giving a soft, intimate feel to the image. The colours are restricted to cool blues and greys with warmer ochres and pale browns.

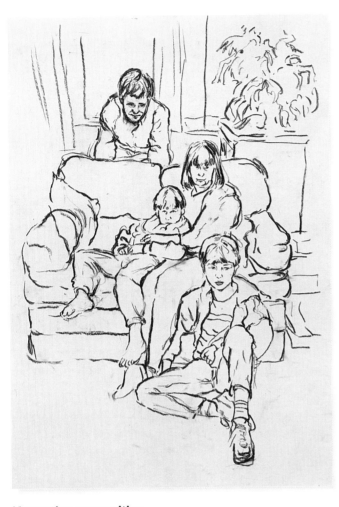

Individual studies

This study of a pair of shoes, drawn in pencil and thin gouache wash, is an assured composition in its own right. The cool bluish-purple shadows of the laces and soles complement the warm buff colour of the shoes and the crimson edging and lining are boldly stated. It is well worth investing time and concentration in such detailed colour studies, even if you choose to incorporate less detail in the final drawing (see pp. 60-61).

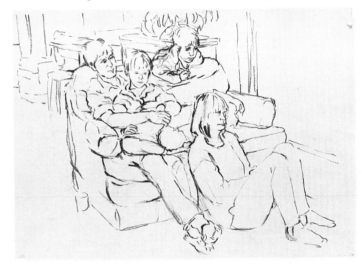

Alternative composition

If the composition takes a vertical format, the viewer's eye is led along a steep diagonal from the figure leaning over the sofa to the boy sitting on the floor. This gives a sense of tension and makes the mood more formal than that of the horizontal compositions.

Angle of viewpoint

The angle of your viewpoint will affect the mood of the image considerably. Viewed from the side, with all the characters looking out of the right-hand side of the picture, this composition has a greater sense of separateness than the previous sketch, as if the subjects are passengers on a train that is about to move out of the station.

Subtleties of mood

In this final sketch in a series of preparatory studies, the artist is concerned less with composition and colour than with the individual characters of the subjects. The narrative has changed; only the two central figures are absorbed in television, while the girl on the left and the man on the right have found something to engage their attention to the left of the picture space. This creates a strange, somewhat detached mood and, as spectators, we are excluded from the image and left to speculate on what is going on.

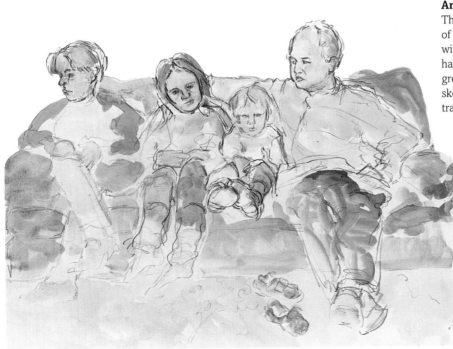

59

FAMILY STUDY

I**F YOU MAKE** the kinds of preliminary sketches previously discussed (*see* pp. 58-59), you can focus on exactly what you want to achieve in your more fully resolved group study. Where some of the exploratory studies had a sense of detachment or formality, the composition of this final study is much more engaged. The artist fully expresses the intimacy and warmth of a family enjoying some moments of relaxation.

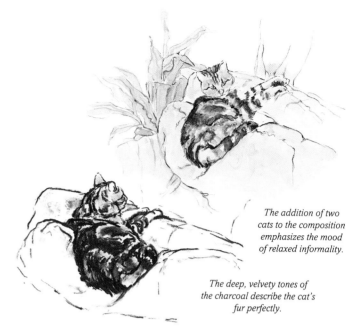

The addition of two cats to the composition emphasizes the mood of relaxed informality.

The deep, velvety tones of the charcoal describe the cat's fur perfectly.

1 ◀ The first marks you make in a group composition are the most important. They summarize each sitter's pose and act as guides when you come to develop the figures individually. Use a thin stick of willow charcoal to make these initial loose outlines, looking constantly from sitter to paper.

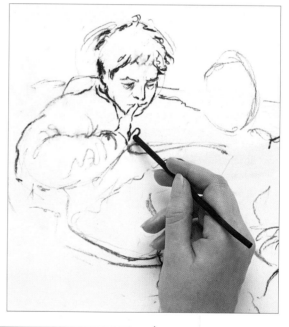

2 ▶ Begin to work up the image, starting with the figure on the left. Include only the basic lines and contours of the clothing and ignore any details. Once you are sure that a contour is exactly right, deepen the tone of the charcoal by applying it with a little more pressure. Finish developing the first figure from top to bottom before beginning the second.

3 ▲ When you draw the feet, do not be tempted to include each shoelace or eyelet, as the drawing could quickly become overworked and fussy. You need only indicate the broad shapes to create a feeling that the form has been satisfactorily completed. Be careful about proportions: a pair of chunky shoes are often larger than you would expect.

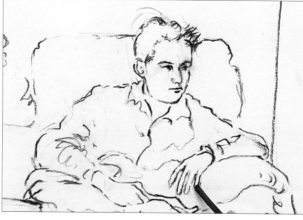

4 ◀ Now work up the figure on the right of the composition, using the proportions and positioning of the first two figures to determine those of the third. Draw the hand falling loosely over the cushion, with the fingers completely relaxed, avoiding details such as knuckles or nails. As you work, try to keep the strength of charcoal line consistent with that used for the completed figures.

5 ▶ Once you have finished the figures, add the cat, using the scale of the sitters' legs and feet to help plot its position. The addition of the cat will create a new point of focus and draw attention to the lower half of the composition. When the charcoal work is complete, review the drawing as a whole and make small adjustments to those areas that seem underworked or less clearly defined than others.

Materials

Willow charcoal

Size 4 sable brush

Watercolour paints

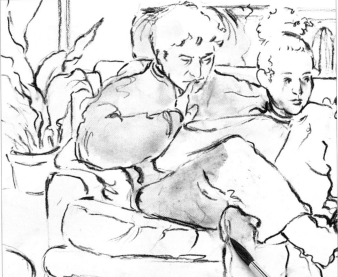

6 ▲ Mix thinly diluted watercolour and apply overall washes with a small soft brush. The colour should enhance the drawing rather than create a painting in its own right, so use only a thin, uniformly toned wash in each area.

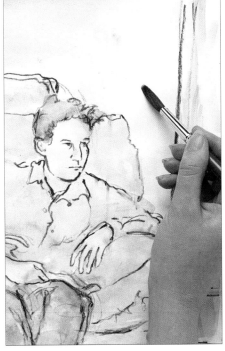

7 ◀ Loosely apply the background colour in a lighter tone than that used for the sofa and just a shade deeper than the paper. This tint will unify the picture and create a warm, softly-lit mood, while the darker tones of the work remain concentrated in the figures.

Family study

The cool tints used for the figures are complemented by the warmer ochre colour of the sofa and background. The addition of the second cat in the centre of the composition, the potted plant on the left and the shoes on the right keep our attention moving around the drawing.

The strong charcoal marks are clearly visible under the delicate watercolour washes.

The figure's bare feet and relaxed pose typify the mood of informality created in this family study.

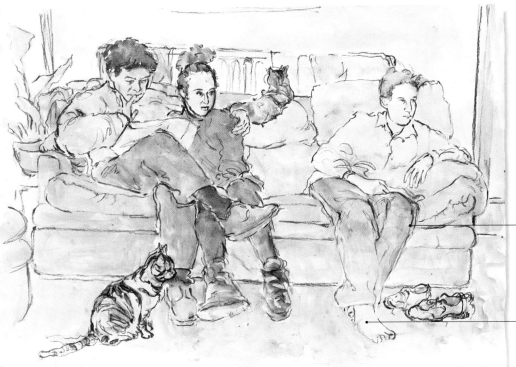

Sue Sareen

LARGE-SCALE WORK

THERE IS A TENDENCY for artists to work on a scale that suits a standard-size drawing board or a sketchbook that can be held comfortably in a lap or on a table. However, it is useful from time to time to open out and draw figures on a much larger scale. When you draw on a relatively small scale, you tend to use only part of your body – the hand and wrist or perhaps the whole arm. But sketching on a roll of paper taped to a wall or on a very large drawing board requires the exertion of your whole body. To make a life-size drawing of a figure, use materials such as charcoal, oil sticks or wax crayons, which give bold marks and cover the paper economically. Such work can also be helpful preliminary material for large-scale paintings (*see* pp. 66-67).

Working freedom
Working on a large scale gives you the freedom to explore line, tone and colour without being restrained by size. It is also an excellent opportunity to master the proportions of a figure.

1 ▶ Loosely sketch the outlines of the face and figure with rapid, fluent lines, allowing the face to emerge from a series of lively, curling strokes. Capture the main elements of the pose, including the position of the hands, and begin to suggest the horizontal lines of the striped jacket. Alternate between compressed charcoal for strong, thick marks and black Conté crayon for thinner, more sensitive lines.

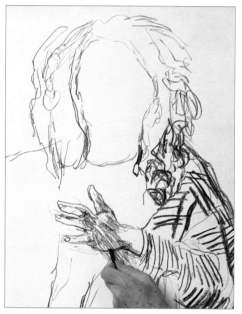

2 ▶ Establish the basic areas of light and shade, adding a sense of weight and solidity to the lower half of the seated figure by shading the dark areas of the trousers vigorously with compressed charcoal. This will also bring the hand forward towards the viewer.

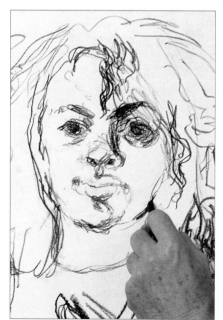

3 ▲ Define the facial features with light, fluid lines, allowing the face to emerge from a series of expressive strokes. Suggest the fall of light from the left by shading firmly with charcoal around the right eyebrow, along the side of the nose and under the chin.

4 ◀ Introduce colour into the drawing with blue and green wax crayons. Press gently where the light falls on the jeans and firmly in areas of deep shadow for a richer effect. The sitter's right hand lies pale and clear, its form and position defined by a series of lines in Conté crayon.

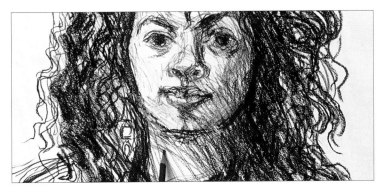

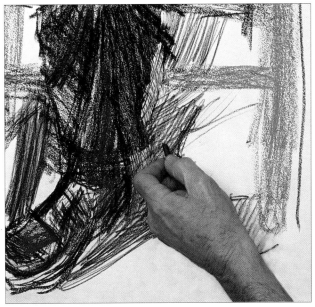

5 ▲ Use a blue coloured pencil to indicate form and tone in the face. The blue tone will give a great boost to the dimensionality of the features, while the texture of the pencil strokes will contrast with the strong, deep marks of the crayon.

6 ▶ Create a web of dark shadows behind the calves and feet with vigorous cross-hatching. A stick of charcoal soaked in linseed oil will give a rich, waxy and smudge-free mark that is ideal for such bold work. Assess proportion for a final time and make any necessary adjustments.

Life-size drawing with colour study

The big, bold drawing retains all the energy and spontaneity of its making. Although there are areas into which the artist has worked more intensively than others, there remains a completeness of feel about the image as a whole. The drawing demonstrates the positive aspects of working on a large scale; the artist has filled the whole length of the paper, utilizing the space on the right to explore the face more chromatically.

In this additional study, the artist uses high-key contrasts to explore the model's colouring.

The sharp lines of the chair echo effectively the angular patterns of the sitter's pose.

Dark shading in the lower half of the drawing plants the figure on the chair with an accurate sense of solidity.

Materials

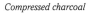

Charcoal soaked in linseed oil

Black Conté crayon

Compressed charcoal

Green wax crayon

Blue wax crayon

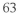

Blue coloured pencil

Hans Schwarz

COMPUTER DRAWING

IT IS UNLIKELY THAT THE PENCIL and paper of the visual artist will ever be made entirely redundant. But artists have always been interested in new technologies and in the ways they can be turned to creative use. Computers are now widely accepted as legitimate tools for making art and there is no reason why the possibilities for figure drawing cannot be extended by their use. There are excellent software packages that create exciting opportunities for image making. However, experimentation does not depend on technology, but on the intuition and imagination of the artist finding new ways of looking at the world and new ways of expressing it.

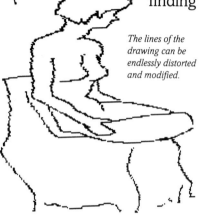

The lines of the drawing can be endlessly distorted and modified.

Transforming an image
The transforming power of the computer gives drawing with it great flexibility. Many simple software packages enable you to transform an image in a variety of ways. Here, a drawing has been made from life simply using a standard mouse. The drawing is filed and copied so that each version can be stretched or modified in different ways.

Pointillist drawings
Here, the artist has used the image of a nude figure captured on video as the basis for pointillist drawings. The drawing proceeds through a number of stages that break down the original photographic image through the application of a series of filters. The first stage is to sharpen the focus and increase the contrast by changing the light and dark balance. Then a pointillise filter is applied, followed by a modification of the dot size and the application of filters that increase the colour saturation.

Modifying colour
An alternative modification of the original image, using different colour filters, produces a drawing with a quite different feel. While the first has a rich intensity produced by the combination of red and black with touches of complementary green, this image has a gentler, sunnier feel with the adjacent harmonies of blue and yellow.

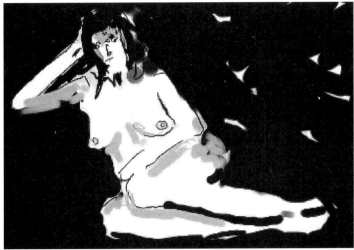

Computer materials

Here, the original video-derived image remains the source for the drawing but it is completely faded out and replaced with the computer equivalent of pen and ink for the detail and deep brush and ink tones for the background. Software packages can be programmed to whatever technical setting the artist requires, such as "charcoal", "gouache" or "add water".

The computer enables the artist to rediscover the rich qualities of brush and ink and give new expression to the figure.

The lines drawn by the electronic pen loosely follow the contours of the figure.

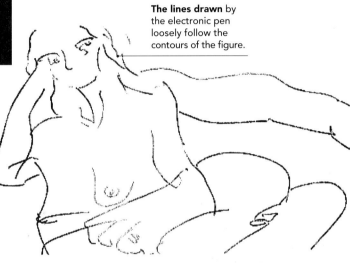

Electronic pen lines

Among more recent innovations are pocket-sized notepads related to the larger graphic tablets on which artists can make drawings using a tool much like a pencil. The digitized image can be fed into a PC and manipulated in an infinite variety of ways before being printed.

Background effects

A professional cordless graphic tablet or electronic pen was used to draw this image from observation in precisely the same way that an ordinary pen or pencil might be used (*right*). But drawing on the computer means that it is possible to experiment freely with background colour (*below*).

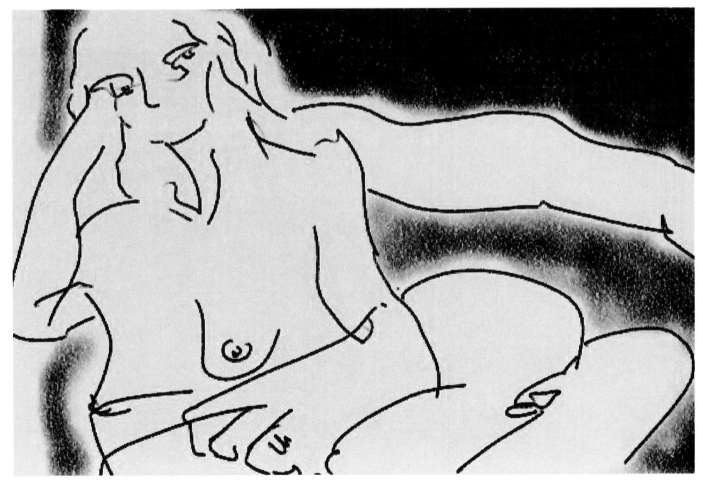

PRELIMINARY STUDIES

MOST ARTISTS WHO make figurative paintings or sculpture rely a great deal on preliminary figure drawing to explore the possibilities for a particular work. The very large-scale sculpture featured here derives from four simple brush drawings, while the painting shows how two intense figure drawings can lead to a complex composition in oils. Once you know your medium well, it is possible to tell with a fair degree of accuracy how a painting or sculpture will turn out simply from a preparatory study. If you are planning a large-scale figure painting, for instance, you can draw a proposed figure full size on paper, cut it out and tape it against the canvas to see how it might look.

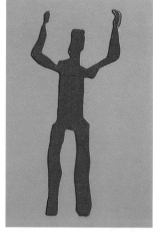

Colour studies
Preliminary drawings can be made in any medium. Here, the artist uses acrylic paint to explore the complementary colours of red and green.

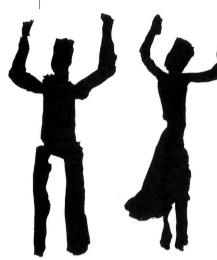

Stencil drawing
This exploratory study has been made by scraping red acrylic colour through a card stencil into damp watercolour paper, allowing the colour to run at the edges.

Drawing for sculpture
This sculpture project was inspired by the artist's idea that a silhouette figure with arms upraised might be read as an expression of celebration or terror. A series of preliminary drawings were made from the imagination, using Chinese brushes and ink. From these, two male and two female figures were selected and their outlines digitized on a computer and used to create the silhouettes in steel plate.

The bold, simple silhouettes of the steel figures clearly echo the preliminary images.

"Red Army" sculpture
Ray Smith's sculpture, "Red Army", shows over a thousand red steel figures about two-thirds life-size on a bed of white gravel, filling a two-acre site. The ambiguity of the figures' pose is central to the work and with so many silhouettes the impact is greatly multiplied. The sculpture has been interpreted by some viewers as a reference to recent history in China or Eastern Europe, by others as more abstract and formal, like a field of poppies against the green landscape.

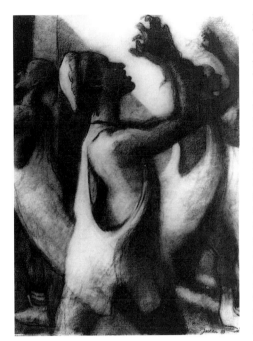

Drawing for painting

These two charcoal studies by Bill Jacklin RA are preparatory work for an oil painting (*right*). The profile of the dancer is a richly patterned drawing, with its many symmetries and interlocking shapes and profiles (*left*). However, the artist has chosen not to incorporate it into his painting in that form, perhaps because it has too complex and self-contained a rhythm. In contrast, the second image engages directly with the viewer and the female dancer appears to invite us to participate in the dance (*below*). Simpler in form and more accessible an image than the first drawing, this provides a better central point for the painting.

"Tompkins Square"

The engagement between the female dancer and the viewer is reinforced in the finished painting, where she is the only figure to be looking directly at the viewer. This focus is a major component of a work in which a number of conflicting elements create a sense of unease.

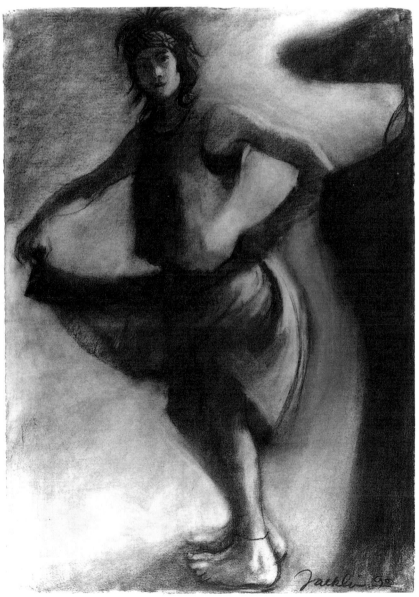

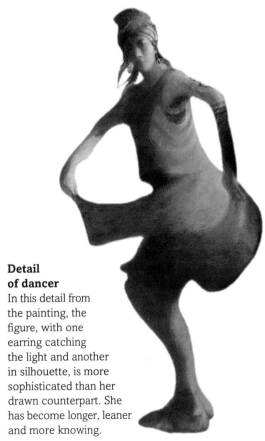

Detail of dancer

In this detail from the painting, the figure, with one earring catching the light and another in silhouette, is more sophisticated than her drawn counterpart. She has become longer, leaner and more knowing.

GALLERY OF NEW IDEAS

THE PHRASE "FIGURE DRAWING" conjures up notions of the life room and of a certain kind of representational drawing. However, there is a whole area of experimental work that comes into the category of drawing but does not necessarily rely on traditional approaches to subject or style. The cut-outs of Matisse have an extraordinary economy based on a lifetime of work with the figure, while Duchamp gives a conceptual, analytical reading of the figure. Other artists work purely from the imagination or from new image sources such as video.

Henri Matisse,
***Blue Nude, the Frog*, 1952,** *141 x 134 cm (55¹/₂ x 52³/₄ in)*
Matisse has cut the shapes that make up the figure from paper pre-painted with gouache. The combination of bright blue and yellow makes the work sing. The figure has an easy nonchalance about the legs, while there is an ambiguity about the arms, which can also be read as tresses of hair. The breasts have the look of eyes and, when the image is seen in this way, the frog analogy becomes clearer.

Jennifer Mellings, *Head Huntress,* *102 x 89 cm (40¹/₄ x 35 in)*
The idea of imagining figures or landscapes in a particular cloud formation is one we have all shared and this allows us to participate in the imagery of this strange charcoal drawing. The vast head huntress, emerging like a Buddha out of the swirling clouds and clasping her own head to her breast as if it were her own child, has an awesome presence. Below, cowed figures scuttle in the shadows, intent on escape or absorbed in their own actions. The drawing tantalizes us with its clarity and its mystery.

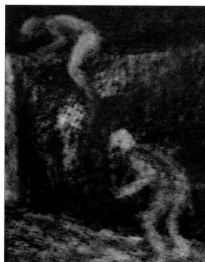

The rich charcoal has been blended with energy and rhythm in this detail, creating an atmosphere of mystery.

Ray Smith, *Family Portrait,* *55 x 75 cm (21¹/₂ x 29¹/₂ in)*
This pastel work is based on a video recording of a family walking around their garden in the afternoon sun. They were not directed in any way in order that the arrangement of the figures might be a natural one. The video was then run and an image chosen using the freeze-frame facility. This was enlarged as a colour photograph and the drawing made from this source. The various pastel colours relate closely to the bright primary and secondary colours of the television screen.

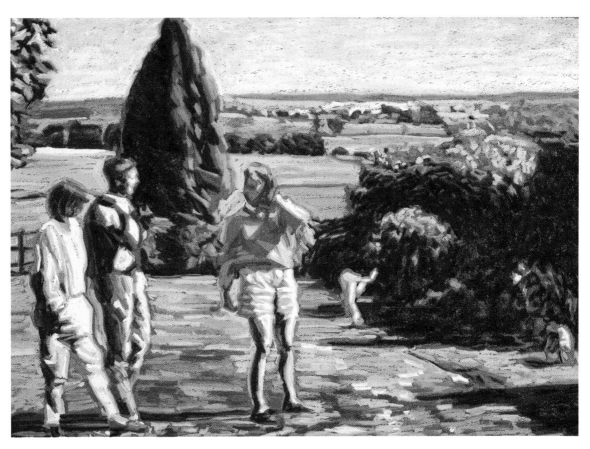

Marcel Duchamp, *Study for the Virgin,* 1912, *40 x 25 cm (15³/₄ x 10 in)*
Early in his career, Duchamp made a number of figure drawings in a traditional representational style. But as his work developed, partially under the influence of Cubism, he began to break up the figure in order to express an image of movement in which "the lines follow each other in parallels while changing subtly to form the movement". His famous painting, "Nude Descending a Staircase", was a landmark in this series of works, which included the "Virgin" drawings, made in the late summer of 1912. This study from the series has been drawn in pencil and watercolour.

The technique of electronically screening the image creates a colour grid that leads to a kind of synthetic impressionism in the drawing.

GLOSSARY

ABSORBENCY The absorbency of a sheet of paper is controlled by the amount of sizing. "Waterleaf" paper has no sizing at all and is completely absorbent. Papers with very little size are known as "soft". The degree of absorbency dictates the way in which the various media perform on the paper surface. A very absorbent paper will soak up a brushstroke immediately, while a well-sized one will allow time for you to manipulate the medium on the surface. With charcoal or pencil, the surface of a soft paper will begin to break up much more rapidly than a well-sized one as you go on drawing and erasing.

ACID-FREE PAPER Paper with a neutral pH. An acidic paper, such as one made with untreated wood pulp, will quickly begin to show deterioration as it yellows and degrades through the action of the acidic content on the fibres. Chemical wood pulp papers are generally neutral and the artist's "rag" papers, now made with cotton fibres, are made to a high standard of purity. Acid-free paper is recommended for any drawing that you wish to preserve in good condition.

BINDER The substance that holds pigment particles together and allows them to adhere to the surface of the support. In acrylic paint, the binder is an acrylic polymer emulsion; in watercolour or pastels, the binder is gum.

BLENDING The physical or optical fusion of adjacent tones or colours. The effect is to create a smooth, gradual or imperceptible transition from one tone or colour to another. This can be achieved by shading techniques such as cross-hatching.

BODY COLOUR *see* **GOUACHE**

CHARCOAL Sticks or lumps of carbonized wood. Charcoal is a traditional drawing material made by firing twigs of willow or vine at high temperatures in the absence of air. Compressed charcoal is a commercial product made from a mixture of Lamp Black pigment and a binding medium.

COLOURED PENCILS Coloured pencil leads are made by mixing pigment with a filler such as chalk and a binder such as cellulose gum. The mixture is compacted and extruded in long, thin rods before being immersed in molten wax and encased in wood.

COMPLEMENTARY COLOURS Two colours of maximum contrast. In painting or drawing, the complementary of a primary colour is the combination of the two remaining primary colours. Thus, the complementary of blue is orange (red plus yellow) and the complementary of red is green (blue plus yellow).

CONTÉ CRAYON Square-shaped crayons which are popular for figure drawing as they hold their shape well and give a rich, strong colour. Traditionally, the iron oxide colours have been popular, in a range from warm red to cool brown, though Conté crayons are now available in a wide range of colours and grades from hard to soft.

CONTOUR SHADING A form of shading in which curved parallel lines are used to show the smooth, rounded forms of the human body. Contour shading echoes the natural curves of the human figure and is useful for defining musculature.

CROSS-HATCHING While hatching is the creation of areas of tone by shading a set of pencil lines closely together in parallel, cross-hatching is simply deepening the tone by overlaying another set of parallel lines at right angles to the first. This can be repeated until the desired depth of tone is achieved.

EASEL A frame for holding a drawing securely while the artist works on it. Artists working outdoors tend to use easels of light construction.

ERASER An eraser is used to remove or modify pencil or other marks. It is not just a negative tool for removing errors but also a positive one for creating useful effects. In the past, artists used rolled pieces of bread or feathers. More recently, they have used standard rubber erasers and soft putty erasers. The latest plastic erasers are extremely clean to use and are also very versatile.

FIXATIVE A surface coating that prevents the dusting or smudging of charcoal, pastel, pencil or other media. Fixative in the form of a vinyl resin in an acetate solvent is commonly available in aerosol form. You should avoid using it in any area that is not very well ventilated.

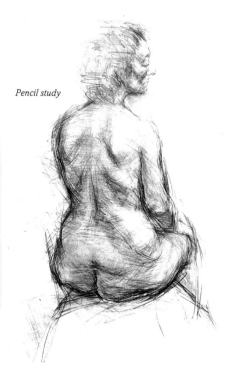

Pencil study

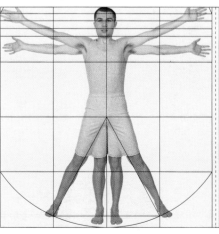

Proportion grid

Watercolour paints and sable brush

FORESHORTENING Foreshortening is the effect of perspective on a figure or object, by which that part of the figure closest to the artist will appear to be proportionately larger than the rest. Foreshortening appears as an exaggerated effect when a prone figure is viewed along its vertical length from either the head or the feet.

FORM Three-dimensional shape.

GOUACHE A type of watercolour paint that is characterized by its opacity. This medium is also known as body colour.

GRAPHITE PENCIL A more accurate name for the so-called "lead" pencil. Graphite pencils are made by mixing powdered graphite – a smooth form of natural carbon – with clay. Thin rods of the mixture are extruded and fired at 1,000 degrees centigrade before being immersed in molten wax and encased in wood.

GRAPHITE STICK A thick graphite lead produced by the same process as for pencil leads. Graphite sticks are not encased in wood but can be fixed in a graphite holder.

HIGHLIGHT The lightest tone in a drawing, usually white or near-white.

HP OR HOT-PRESSED PAPER The smoothest of the three main types of surface in artist's paper. In the case of mould-made paper, it is obtained by passing paper through calender rollers and in handmade paper by a system known as plate glazing.

HUE Describes the basic colour of an object, such as red, yellow or blue. "Hue" does not describe how light or dark the colour is ("value") or how saturated or intense it is ("saturation" or "chroma").

LINE DRAWING A drawing technique in which the subject is defined through the use of outline rather than with tonal shading.

MODELLING Giving a three-dimensional appearance to an image by tonal shading or other mark making.

MONOCHROMATIC A monochromatic drawing is made with a single colour but it can show a full range of tones.

NEGATIVE SPACES The shapes created between objects or parts of objects. If a figure is standing with one hand on his or her hip, the triangular space between the arm and the body is a negative space.

NOT OR CP (COLD-PRESSED) PAPER NOT paper has a medium or fine grain surface, mid-way between HP (smooth) and Rough. On artist's mould-made papers the surface is created when the paper is taken through a press on a felt or blanket, the texture of which is imprinted on the paper.

OIL PASTEL A crayon for drawing made from a mixture of pigment, hydrocarbon waxes and animal fat.

PROPORTION In figure drawing, proportion is the establishing of an accurate relationship between the parts of the body and the body as a whole.

ROUGH PAPER Rough paper is the most heavily textured of the three main types of surface in artist's paper. A coarse weave is used for the felt which imprints the texture on the paper as it passes through the press.

SABLE Mink tail hair used to make fine watercolour brushes.

SCUMBLING A technique in which semi-opaque or thin opaque colour is loosely brushed over an area so that patches of the colour beneath show through.

SILVERPOINT A method of drawing using a thin silver wire in a holder on paper coated with white gouache.

SOFT PASTEL The most common and traditional form of pastel made by mixing pigment with chalk and binding it with a weak gum solution.

STUMP Also known as torchon, this is a pencil-shaped tool made of tightly rolled paper and used to soften tones during drawing.

SURFACE The texture of the paper. In Western papers – as opposed to Oriental – the three standard grades of surface are HP (Hot-pressed), NOT or CP (Cold-pressed) and Rough.

TINT Colour mixed with white. In the case of watercolour, a similar effect is achieved by thinning the paint with water and allowing more of the white surface of the paper to be reflected through it.

TONE The degree of darkness or lightness.

WASH An application of well-diluted paint or ink.

WATERCOLOUR Paint made by mixing pigments with a water-soluble binding material such as gum arabic.

Pencil and watercolour study

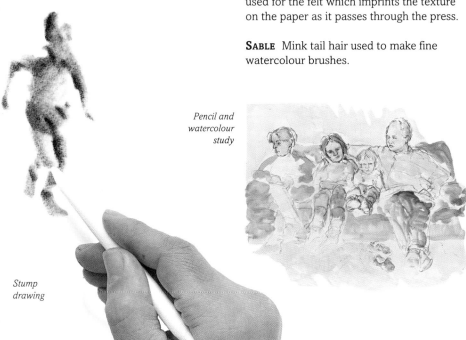

Stump drawing

> ### A NOTE ON MATERIALS
>
> • Avoid using Chrome colours when you work with watercolour as they carry a significant health risk. There is a lesser danger with other pigments, such as the Cadmiums, provided artists take sensible precautions and avoid licking brushes with paint on them.
>
> • Soft pastels generate a good deal of dust so it is best to avoid inhaling the pigment powder as far as possible.
>
> • The brush sizes given in this book refer to Winsor & Newton brushes. They may vary slightly from those of other manufacturers.

INDEX

ACKNOWLEDGEMENTS

Author's acknowledgements

Ray Smith would like to thank Louise Candlish and Claire Pegrum at Dorling Kindersley for organising the project so well. Thanks to Louise for taking care of the editing with such skill and amiability and for her many helpful suggestions and to Claire for all her ideas and careful work on the designs and her own sensitive drawings. Many thanks to the rest of the team at Dorling Kindersley, including Jo Walton, Toni Kay, Gwen Edmonds, Sean Moore, Suchada Smith, and to photographer Steve Gorton and his assistant Sarah. Thank you also to the artists and owners of the works which enliven this book and in particular to the artists who made drawings especially for it. Drawing under pressure in the photographic studio is not so easy and our artists have done so uncomplainingly and in a great spirit of co-operation. Thanks to all the models, Jo, Vince, Zirrinia, Tassy, Stefan and Mr George Baxter, who have sat for drawings especially for this book and to those whose images appear from the pages of past sketchbooks.

Picture Credits
Key: *t*=top, *b*=bottom, *c*=centre, *l*=left, *r*=right, *a/w*=artwork; RAAL=Royal Academy of Arts Library.
Endpapers: Jane Gifford; *p2:* Neale Worley; *p3:* Sue Sareen; *p4:* Neale Worley; *p5:* *tl* Postcard of *Friends* by Norman Hepple RA, RAAL; *lc*

Sue Sareen; *rc* Ray Smith; *bl* Neale Worley; *p6:* *t* Courtesy of Ray Smith; *c* Neale Worley; *l* Ray Smith; *pp6/7:* Thomas Rowlandson, *Drawing from Life at The Royal Academy at Somerset House, London,* 1811, RAAL; *p7:* *tl* Neale Worley; *t* Gauguin, *Noa Noa,* facsimile edition (1987), with thanks to Editions Avant et Après; *p8/9:* All Ray Smith; *p10/11:* All Ray Smith; *p12:* *lc* Richard Bell; *p14:* *t* Linda Hardwicke; *bl* Nahem Shoa; *bl* Ray Smith; *p15:* *l* Aury Shoa; *tr* Neale Worley; *c, cr* Ray Smith; *p16:* Postcard of *Friends,* Norman Hepple RA, RAAL; *All* Ray Smith; *p17:* Muybridge, *Animal Locomotion,* Plate 204, 1887, © The Art Institute of Chicago, All Rights Reserved; *All Ray Smith; p18:* All Ray Smith; *p19:* *tl, tr, cr* Nahem Shoa; *l* William Wood; *p20:* *tr* Sue Sareen; *b* Gauguin, *Noa Noa,* facsimile edition (1987); *p21:* *l* Eileen Cooper, courtesy of Benjamin Rhodes Gallery, London; *tr* Nahem Shoa; *cr* Pablo Picasso, Sketchbook No. 76, page 37, RAAL/©DACS 1994; *p22:* *tl* Vesalius, *Humani Corporius* 1545; *p23:* *l* Neale Worley; *p25:* *c, br* Neale Worley; *p26:* *tl* Neale Worley; *tr* Ray Smith; *c* Nahem Shoa; *p28:* *t* Leonardo da Vinci, The Royal Collection ©1994 Her Majesty Queen Elizabeth II; *bl* Kollwitz, Käthe Kollwitz Museum, Cologne/©DACS 1994; *p29:* *tl* Benjamin Robert Haydon RA, RAAL; *t* Tintoretto, Courtauld Institute Galleries, London, Seilern bequest 1978; *b* Neale Worley; *p36:* *t* David Jones, National Museum of Wales/Anthony d'Offay Gallery, London/Trustees of the Estate of David Jones; *b* George Michael Moser RA, RAAL; *p37:* *t* Toulouse-Lautrec, Philadelphia Museum of Art: Purchased: John G. McIlhenny Collection; *b* Linda Hardwicke; *p40:* *tr* Neale Worley; *p41:* *l* Hans Schwarz; *tr* ©ALLSPORT/Bob Martin; *p44:* *t* Angela Waghorn; *b* Vuillard, Bibilothèque de l'Institut de France, Paris/Photo: Alison Harris/©DACS 1994; *p45:* *t* Van Dyck, Devonshire Collection, Chatsworth. Reproduced by Permission of the Chatsworth Settlement Trustees; *b* Hans Schwarz; *p50:* *t* Neale Worley; *b* Gwen John, Stanford University Museum of Art 1976.136.1 Gift of Thomas A. Conroy; *p51:* *t* Leonard Rosoman RA, RAAL; *b* Seurat, The Berggruen Collection, reproduced by Courtesy of the Trustees of the National Gallery, London; *p 52:* *c* Ghislaine Howard; *bl* Sue Sareen; *pp52/53:* *a/w* by Richard Bell; *p53:* All Neale Worley; *p56:* *t* Mandy Lindsay; *b* Sue Sareen; *p57:* *tl* Beckmann, Staatliche Museen Kassel. Photo: Brunzel 1994/©DACS 1994; *tr* Kate Hayden; *bl* Avigdor Arikha, Private Collection; *pp58/59:* All Sue Sareen; *p62:* *tl, cl* Ray Smith; *cr, bl* Jeremy Diggle; *p63:* All Jeremy Diggle; *p66:* All Ray Smith; *p67:* *tl* *Dancers: Tompkins Square III,* Bill Jacklin RA, 1989, Marlborough Gallery, New York; *bl* *Dancers Tompkins Square,* Bill Jacklin RA, 1990, Marlborough Gallery, New York; *tr, br* *Tompkins Square,* Bill Jacklin RA, 1990, Marlborough Gallery, New York; *p68:* *t* Matisse, Sammlung Beyeler, Basel/© Succession H. Matisse/DACS 1994; *b* Jennifer Mellings; *p69:* *t* Ray Smith, courtesy of Peter Degermark; *b* Duchamp, Philadelphia Museum of Art: The Louise and Walter Arensberg Collection/©ADAGP Paris and DACS, London 1994.

p23: Models of Superficial skeletal muscles (back view and front view) by: